DRAWI[...] [...]ROM THE
FAMOUS ARTISTS SCHOOL

DRAWING LESSONS FROM THE
FAMOUS ARTISTS SCHOOL

CLASSIC TECHNIQUES AND EXPERT TIPS FROM THE GOLDEN AGE OF ILLUSTRATION

STEPHANIE HABOUSH PLUNKETT
CHIEF CURATOR, NORMAN ROCKWELL MUSEUM

MAGDALEN LIVESEY
PRESIDENT, CORTINA LEARNING INTERNATIONAL

ROCKPORT

Quarto is the authority on a wide range of topics.

Quarto educates, entertains and enriches the lives of our readers—enthusiasts and lovers of hands-on living.

www.QuartoKnows.com

© 2017 Quarto Publishing Group USA Inc.

First published in the United States of America in 2017 by
Rockport Publishers, an imprint of
Quarto Publishing Group USA Inc.
100 Cummings Center
Suite 265-D
Beverly, Massachusetts 01915-6101
Telephone: (978) 282-9590
Fax: (978) 283-2742
QuartoKnows.com
Visit our blogs at QuartoKnows.com

Authors' Note: The information cited in some of the captions has been adapted from documentation on the Norman Rockwell Museum website: www.illustrationhistory.com.

10 9 8 7 6 5 4 3 2 1

ISBN: 978-1-63159-122-8

Library of Congress Cataloging-in-Publication Data

Names: Plunkett, Stephanie Haboush, author. | Livesey, Magdalen, author. |Famous Artists School (Westport, Conn.)
Title: Drawing lessons from the Famous Artists School : classic techniques and expert tips from the golden age of illustration / Stephanie Plunkett,
 Chief Curator, Norman Rockwell Museum; Magdalen Livesey, Cortina Learning International.
Description: Beverly : Rockport Publishers, 2017. | Series: Art studio classics
Identifiers: LCCN 2016056735 | ISBN 9781631591228 (paperback)
Subjects: LCSH: Drawing--Technique. | Norman Rockwell Museum at Stockbridge.
 | BISAC: ART / Techniques / Drawing. | ART / Techniques / Pencil Drawing. | ART / Techniques / General.
Classification: LCC NC650 .P59 2017 | DDC 741.2--dc23
LC record available at https://lccn.loc.gov/2016056735

Cover Design and Page Layout: Landers Miller Design
Front Cover Art: Al Dorne
Front Flap: Austin Briggs
Back Cover (Left to Right): Jon Whitcomb, Norman Rockwell, Alfred Charles Parker, and Jon Whitcomb
Printed in China

MIX
Paper from responsible sources
FSC® C104723
www.fsc.org

ACKNOWLEDGMENTS

Dedicated to the art of illustration in all its variety, Norman Rockwell Museum in Stockbridge, Massachusetts, is honored to have partnered with Rockport Publishers on *Drawing Lessons from the Famous Artists School: Classic Techniques and Expert Tips from the Golden Age of Illustration*. Inspired by the generous donation of thousands of original artworks and archival materials from the Famous Artists School to the museum's permanent collection by Magdalen and Robert Livesey, owners of Cortina Learning International and Famous Artists School, the book honors the legacy of twelve legendary illustrators who sought to ensure that others would inherit the traditions, skills, and professionalism that they practiced and preserved.

Sincere thanks to my outstanding writing partner, Magdalen Livesey, for her enthusiasm and dedication to this project and to my talented colleagues, Barbara Rundback and Venus Van Ness, who have worked tirelessly to accession and digitize thousands of studies, final artworks, photographs, course books, and archival records for publication and access. Their interest in the material and camaraderie throughout the process have provided much inspiration. Appreciation also goes to Andrew Sordoni, who has generously supported the processing of this important collection of materials and to Joy Aquilino and John Gettings of Rockport Publishers for their guidance and recognition of the timeless lessons contained within.

Heartfelt thanks to Director/CEO Laurie Norton Moffatt and Norman Rockwell Museum curatorial team members Martin Mahoney, Thomas Mesquita, Joseph Tonetti, Mary Melius, and Jesse Kowalski for their support of this effort in so many ways and to our dedicated Cortina Learning International champions, George Bollas and Carol Bennett, for their ongoing care for the collections, which has ensured their preservation. We hope that this book will foster the enjoyment and learning intended by the Famous Artists School illustrators and the many artists and administrators working behind the scenes in mid-century America to bring their lessons to life.

Stephanie Haboush Plunkett
Deputy Director/Chief Curator
Norman Rockwell Museum

CONTENTS

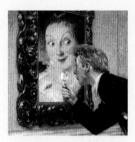

1

THE ART OF
THE STORY

Explore the process of creating a visual narrative, from the initial story concept and progressive stages of editing to a finished work of art.

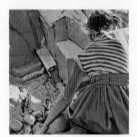

2

MAKING IT
PERSONAL

Learn to create imagery that expresses your personal point of view by infusing yourself and the world around you into your art.

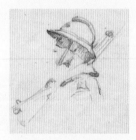

3

DRAWING AS A
TOOL FOR SEEING

Creative approaches to drawing that let the mind roam free and help ideas take shape are explored in this chapter.

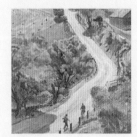

4

COMPOSING FOR
BEST EFFECT

Compositional advice from the Famous Artists offers important tips on attracting and leading the viewer's eye, establishing a center of interest and point of view, and creating a strong sense of mood and drama in your art.

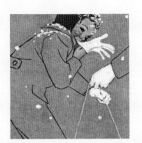

5

THE WELL-DESIGNED IMAGE

Position, balance, color, contrast, size and scale, attitude, and the use of symbolic elements are explored by the Famous Artists, who were all gifted designers as well as illustrators.

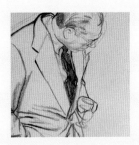

6

DRAWING THE FIGURE

Portraying the figure in motion and in space, casting and working with models, and creating photographic reference for your art are themes that are explored.

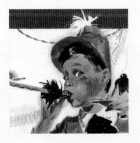

7

AN EYE FOR COLOR

Color's creative uses, as well as thoughts on what color is, how to organize it, and how to employ it to its greatest impact, are considered in this chapter.

WELCOME

Drawing Lessons from the Famous Artists School offers a lively, inspirational exploration of the creative methods of America's most highly regarded illustrators, whose influential narrative artworks reached millions on the covers and pages of the nation's most popular mid-century publications.

Emerging from a long period of political and economic transformation following the Great Depression and World War II, Americans began to reimagine themselves and the new lives that they hoped to lead. Directly linked to commerce and the "American dream" of affluence for all, magazines published aspirational images depicting an ideal standard of living. To engage audiences, publishers utilized the talents of artists, whose illustrations were seen and enjoyed by millions. Top publications boasted subscriptions of 2 to 9 million during the 1940s and 1950s, and copies were shared among family and friends, bringing readership even higher.

The engaging lessons, sage advice, and creative approaches featured in this book reflect those of the Famous Artists School founders—twelve exceptional visual communicators who achieved legendary status in their time. The twelve Famous Artists were more than tastemakers—they played a crucial role in affecting the dreams and aspirations of their day. The Famous Artists School course promised "A Richer Life Through Art" for those pursuing the dream of an art career.

Among the book's featured artworks are those from the Famous Artists School Collection at Norman Rockwell Museum in Stockbridge, Massachusetts, which preserves and shares a growing resource relating to Norman Rockwell and the art of illustration, the role of published imagery in society, and the American twentieth century.

We are delighted to share these timeless lessons and the wisdom of these exceptionally talented artists, who put their experience to work in support of emerging and experienced artists and their creative development.

JOHN ATHERTON
(1900-1952)

"If you can successfully transmit your impressions of a subject, reduced to its essential properties through your own personality, the result will be not only a record or comment about what you see but also an expression of yourself, and as such, unique and your very own."

AUSTIN BRIGGS
(1908-1973)

"Empathy—the ability of the [artist] to feel what his characters must be feeling—is fundamental to an illustrator's success."

STEVAN DOHANOS
(1907-1994)

"Nature, man and dreams, and manmade objects form the basis of almost all paintings. [Artists] are absorbed in expressing the relationship among the three."

AL DORNE
(1906 – 1965)

"Drawing is the art of observation and communication . . . the most important consideration in making pictures. If you're able to draw you can devote yourself to saying what you think and feel."

ROBERT FAWCETT
(1903 – 1967)

"You need not worry about your technique. Your technique is your manner of working, which comes from your manner of thinking and feeling. It will be impossible to avoid developing a 'style' eventually, but hold off for as long as you can."

PETER HELCK
(1893 – 1988)

"To me, composition is the foundation of all satisfying art, whether music, architecture, sculpture, or making pictures."

FRED LUDEKENS
(1900 – 1982)

"I think experience is the best teacher . . . you learn by doing, seeing, and understanding."

ALFRED CHARLES PARKER
(1906 – 1985)

"Working in different mediums can be exciting. I enjoy it and find that it stimulates me and helps keep my work fresh."

NORMAN ROCKWELL
(1894 – 1978)

"The idea and the presentation both are important but there is a tendency to emphasize technical skill and facility and ignore the creative thought which is the foundation of successful picturemaking."

HAROLD VON SCHMIDT
(1893 – 1982)

"The interesting and challenging fact is that variety can never be exhausted as long as creative thinking and feeling exist."

BEN STAHL
(1910 – 1987)

"In studying art, never stop consulting the greatest organizer of all—Mother Nature."

JON WHITCOMB
(1906 – 1988)

"Next to faces, people seem to notice hands first in illustrations, and there is a widely held belief that hands are a better indication of character than faces."

About the Famous Artists School

Begun in 1948 and based in Westport, Connecticut, the Famous Artists School became America's most popular art correspondence school. In the late 1940s, the executives of New York's Society of Illustrators conceived a plan to begin a school to impart their expertise and help to support the Society. Due to the organization's nonprofit status, the Famous Artists School operated independently for profit, with former Society of Illustrators president Albert Dorne at its head.

The initial volumes of lessons gave in-depth, practical how-to instruction in the working methods from the illustrators listed on the previous spread. Over time, selected lessons from individual courses were compiled in four-volume sets focusing on narrative picturemaking, from idea to finished illustration. Revised annually, the course was occasionally updated with new lessons and contributing illustrators.

In 2014, Norman Rockwell Museum was the fortunate beneficiary of a substantial collection of original art and archival materials from the Famous Artists School's most recent owners, Magdalen and Robert Livesey. The collection reveals not just the working methods of the nation's most noted visual storytellers, but the ways in which art was viewed as a path to a creative and successful life. Remarkably, the courses attracted more than 60,000 students during the post-war era of the 1940s and 1950s, and employed more than one hundred artists, who carefully and thoughtfully corrected assignments and judged art competitions in the hope of advancing students' abilities and prospects for a viable career. Their lessons and observations are as relevant today as they were when first introduced.

Publicity photograph of the founding Famous Artists School faculty with paintings created for Cecil B. DeMille's 1949 film *Samson and Delilah*. *Left to right*: Harold von Schmidt, John Atherton, Al Parker, Al Dorne (*laying on the ground*), Norman Rockwell, Ben Stahl, Peter Helck, Stevan Dohanos, Jon Whitcomb, Austin Briggs (*rear, far right*), and Robert Fawcett (*front, far right*). Illustrator Fred Ludekens is not pictured. Photograph by Pagano Studios, New York.

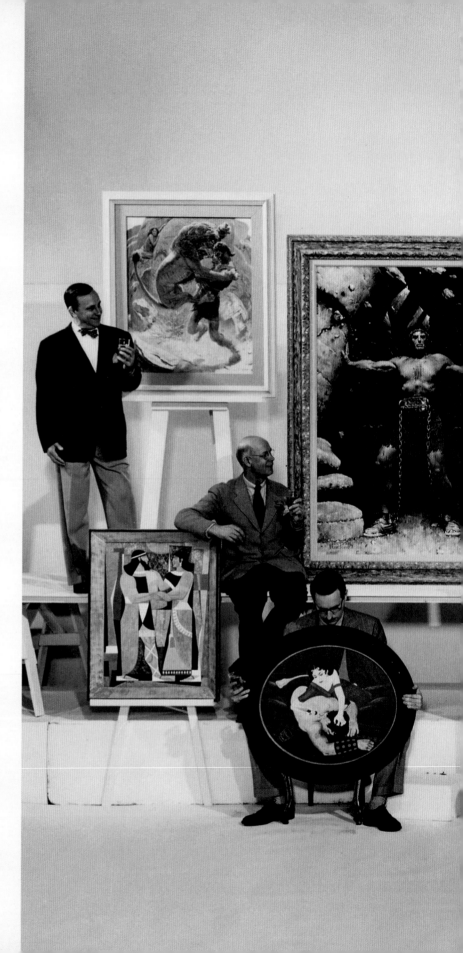

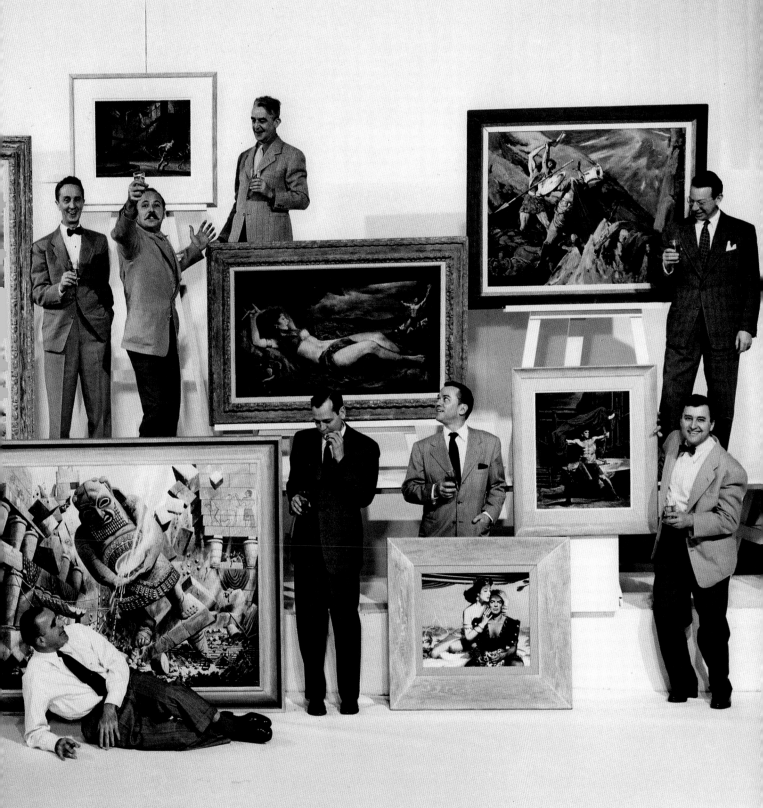

1 THE ART OF THE STORY

For illustrator Norman Rockwell, "the story was the first thing and the last thing," the essential underpinning of each of his illustrations—a sentiment echoed by his Famous Artists School colleagues. Their lessons and commentary explore the process of creating a visual narrative, from the initial story concept and progressive stages of editing to the finished work of art.

A consummate visual storyteller and a masterful painter with a distinct, personal message to convey, Norman Rockwell constructed fictional realities that offered a compelling picture of the life that many twentieth-century Americans aspired to. Anxiously awaited and immediately understood, his seamless narratives seemed to ensure audience engagement with the publications that commissioned his work. The complexities of artistic production remained hidden to his enthusiasts, who were compelled by his vision and content to enjoy his art in the primary form for which it was intended—on the covers and pages of their favorite magazines. What came between the first spark of an idea and a published Rockwell image was anyone's guess, and far more than readers would have ever imagined.

Conceptualization was central for the artist, who called the history of European art into play and employed classical painting methodology to weave contemporary tales inspired by everyday people and places. His richly detailed, large-scale canvases offered far more than was necessary, even by the standards of his profession, and each began with a single idea. Admittedly "hard to come by," strong picture concepts were indispensable. From the antics of children to the nuanced reflections on human nature that he preferred, each potential scenario was first cemented with a simple thumbnail sketch. What followed was a carefully orchestrated process of image development that demanded the careful integration of aesthetic concern, graphic clarity, and the effective use of technology.

Norman Rockwell
Art Critic, 1955
Cover illustration for
The Saturday Evening Post,
April 16, 1955
Oil on canvas

THE BIG IDEA: DEVELOPING PICTORIAL CONCEPTS

Norman Rockwell once said he envied students who swooned when viewing the *Mona Lisa* because he never felt such passion. Rockwell may have seen himself as a more analytical artist, such as the one examining a seventeenth-century Dutch painting in his 1955 *Art Critic* (see previous spread). His original draft depicts a student examining painter Frans Hals's technique in a portrait of a Dutch housewife. In that study, a landscape on an adjacent wall places the student in a gallery of Dutch artwork. But a recurring Rockwell theme of fantasy and reality exchanging places seems to have taken over, and the painting changes course.

With typical humor, Rockwell replaces the dour woman with one more alluring, based on a Peter Paul Rubens portrait of his wife, Isabella Brant. The landscape has become a group of Dutch cavaliers, brought to life with animated facial expressions. They are wary and concerned. Is the student getting too close to the painting? Is he being too personal with their gallery colleague? The scene's movement from reality to fantasy establishes a lively tone that proved engaging for his audience.

Getting the Idea: The Thumbnail Sketch

"It is extremely important to develop a [concept] that is good. No matter how well you paint a storytelling picture, if the idea is not good it will be a failure and people will ignore it," Rockwell noted in the Famous Artists School course. "When I have an idea . . . I try it out on everyone I can induce to look at my sketch. If people seem uninterested or only mildly interested, I abandon the idea and search for another. Only when people become enthusiastic do I become enthusiastic, and then I am anxious to get to painting." In the drawing below, Rockwell's bohemian model studies the portrait on the wall carefully. He is still unsure of what will go into the larger frame to the right, but his thumbnail sketch visualizes his basic concept.

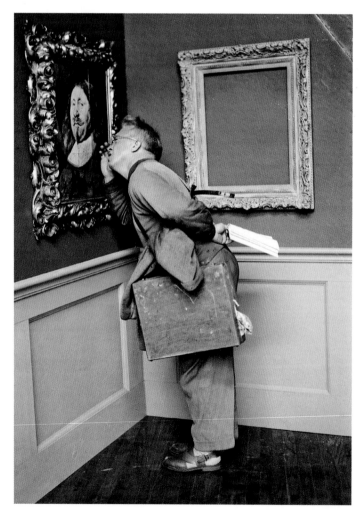

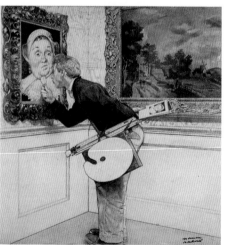

(*All images on this spread*)
Norman Rockwell
Studies and photographic reference details for *Art Critic*, 1955
Cover for *The Saturday Evening Post*,
April 16, 1955

"If your people are to look real, your models must be real people, not imaginative." As in the work of countless artists, autobiographical elements served as inspiration for many of Rockwell's artworks. His original model for *Art Critic*, seen here, would eventually be recast as his oldest son, Jarvis Rockwell, who was an art student at the time. Rockwell's neighbors, friends, and family—and even the artist himself—were recruited to pose for his pictures.

Creating Authenticity: Models and Props

According to Rockwell, "After getting the right idea, getting the right model to put over the idea is important." Casting Rockwell's models required a directorial eye. Scouting models and locations, researching costumes and props, he carefully orchestrated each element of his design before putting paint to canvas.

For the reference shot shown opposite, far left, he assembled a corner wall, complete with traditional museum frames found in antique and "junk" shops. "Having searched for and found desirable props, you must be sure they are authentic," he said. Staging his scenarios for the camera, the artist instructed his photographers when and what to shoot as he directed a cast of amateur actors. He produced a wealth of photographs for every new composition, which he then transferred, in whole or in part, to his final work. Avoiding stark contrast, Rockwell's reference photos captured a plethora of details and the essential information needed to tell compelling stories and create realistic drawings and paintings.

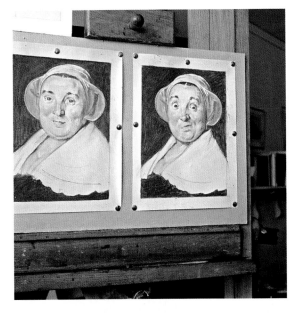

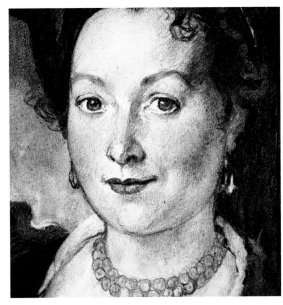

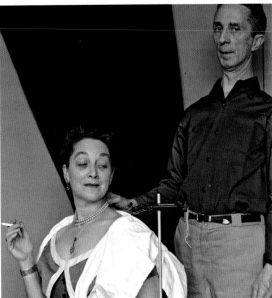

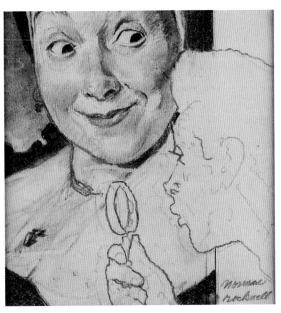

(*Details, clockwise from above left*) Rockwell struggled to find the right subject, style, and attitude for the portrait under scrutiny in *Art Critic*. He began with an image inspired by the art of seventeenth-century Dutch painter Frans Hals, which proved too serious for his composition, and eventually turned to Flemish Baroque painter Peter Paul Rubens for help. After creating his own version of Rubens's *Portrait of Isabella Brant*, c. 1621, he invited his wife, Mary Rockwell, to portray the more flirtatious interactive figure that appears in the final work. For this photograph, a diaper cloth, which Rockwell used to clean his brushes, became a makeshift shawl.

Color and Expression

"After doing the preliminary sketch in which I attempt to solve most of my problems except color, I tackle color by making a color sketch," Rockwell said. The panels below, painted on acetate over a warm ochre ground, allow Rockwell to consider a variety of expressive solutions that will strengthen his narrative. He explained, "Color can aid greatly in expressing an idea and very often can set the mood of your picture. If your picture is an amusing one, the color should express gaiety," as was the certainly the case in *Art Critic*.

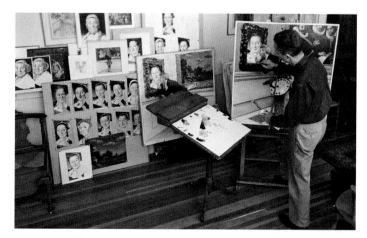

Norman Rockwell in his Stockbridge, Massachusetts, studio surrounded by his many studies for *Art Critic*.

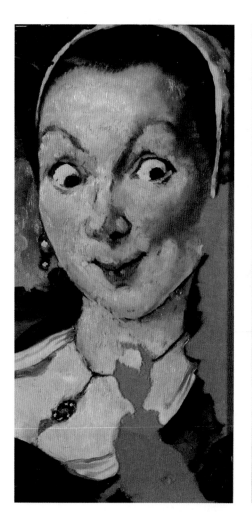
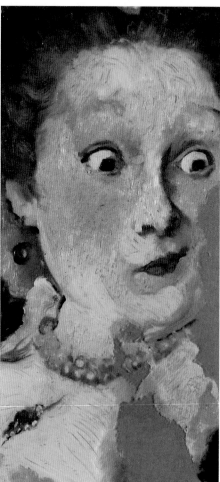
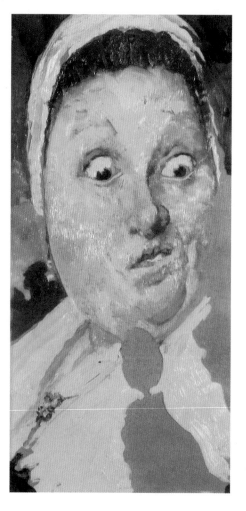

Color study details for *Art Critic*, 1955, cover for *The Saturday Evening Post*, April 16, 1955. Oil on acetate board.

CHARACTER, PLOT, AND SETTING

Just as in works of literature, character, plot, and setting play important roles for narrative artists—often in varying degrees, depending upon the intent of their piece. Character is the "who," plot is the "what," and setting is the "where and when" of any visual story, and each of the Famous Artists had a different approach to incorporating these elements. When reading through a manuscript to create an editorial illustration, Jon Whitcomb visualized the story as a movie. "Viewed this way, the big scene or scenes aren't hard to locate," he said. "Some stories lend themselves to interesting poses and layouts.

Others haven't much action at all, in which case the artist must invent some . . . or plan a mood illustration which will give the reader a quick impression."

Skillfully executed, extreme close-ups of attractive young women for large-format women's magazines were illustrator Jon Whitcomb's stock in trade. His "character" paintings emphasized the play of light and shadow on his subjects in arresting works that accentuated subtle expressions and distinctive facial features, from well-defined eyebrows to full lips and high, contoured cheekbones.

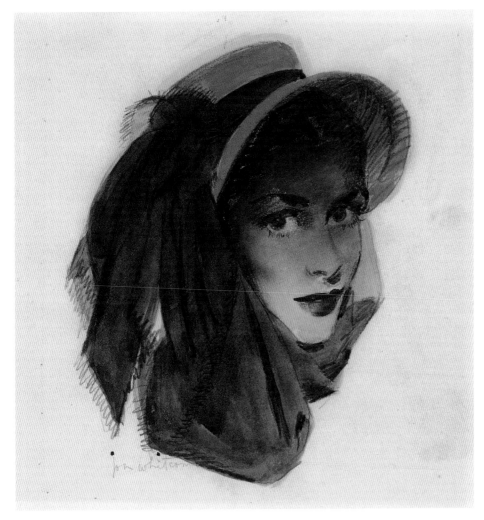

Jon Whitcomb *Woman in Hat,* c. 1948. Watercolor on paper
In this study, Whitcomb imbues his subject with a sense of mystery by angling her face away from us while diverting her glance toward us and casting a shadow over her forehead and brows. Red lips and the whites of the model's eyes become eye-catchers in an otherwise somber image.

NOW YOU TRY IT!

INSPIRED BY LIFE

Come up with three art concepts inspired by events in your own life, and sketch them out in rough thumbnail drawings measuring about 3" x 5" (7.5 x 12.5 cm).

- What story are you are trying to tell?
- What characters, details, and settings would best convey your ideas?
- Of the three drawings, which is the strongest and most authentic?
- Is there a single element in your chosen work that should be replaced to strengthen your concept?
- Might you introduce an element of fantasy in your concept, as in Rockwell's *Art Critic*?

Now develop your favorite thumbnail into a more finished work by gathering references and refining picture elements in the medium of your choice.

In 1944, Adela Rogers St. Johns's *Government Girl* series inspired a popular feature film by the same name. The movie's starring actress, Olivia de Havilland, played the lead role, "a secretary who knows the political ropes—and her own mind."

In the work below, Al Parker draws viewers into the plot of a fictional story inspired by a wartime narrative. The artist's two shadowy figures are effectively realized. A tall man advances toward the story's heroine, Defense Department secretary Elizabeth Allard, who leans away from him in a defensive and vulnerable stance. Framing his subject, a backlit window display is stocked by such unremarkable items as an aloe plant, a slender teapot, a cast iron cow, hammered copper plates, decorative brackets, and a ceramic planter. The planter—a kind of spy—appears to monitor the action between the figures. Aside from this narrative detail, the entire display earns its keep by virtue of its abstract arrangement and the visual pleasure it provides. During this period, Parker began to emerge as an illustrator with an abstractionist's sensibility.

NOW YOU TRY IT!

CHARACTER, PLOT, AND SETTING

Illustrate a fiction or nonfiction story of your choice from three different perspectives.
- Create a close-up of a character described in the story.
- Home in on a compelling aspect of the plot or storyline.
- Design an image that emphasizes the story's setting.

Notice how this sequence of images each contributes to the overall visual narrative, and consider which might be the most effective. What makes you feel that way?

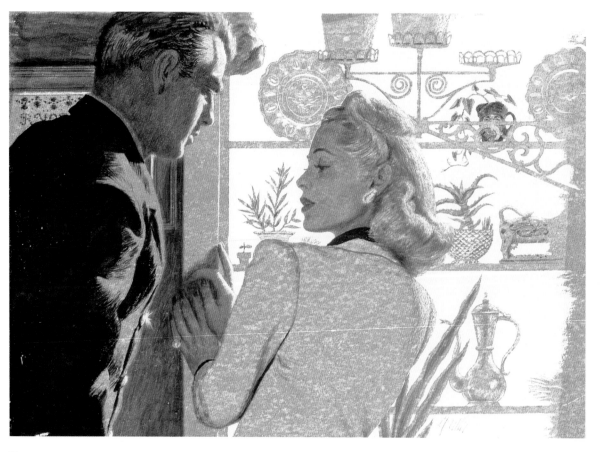

Alfred Charles Parker
Illustration for
Government Girl by
Adela Rogers St. Johns
Ladies' Home Journal,
January 1943
Gouache on panel

MOOD, MOVEMENT, AND EMOTION

"Even before the artist has a very definite visual idea of what [to] paint, he already knows what [the] subject is going to be about in a general way. He has decided what the emotional content of the picture will be. Most effective pictures try to get this across in one single message," said Austin Briggs, who believed that a story concept should be able to be summed up in one sentence. In storytelling images, Briggs advised artists to home in on a detail that means something to them. "I start where I am the most sensitive. The more the situation means to me, the more meaning I can give it for others." But Briggs clearly understood the interests of his audience as well.

For the advertising illustration below, Briggs paints a narrative with universal appeal—an anticipated visit from family for the holidays. The artist invites his viewers to identify with the children who anxiously await their grandmother's arrival. We look over their shoulders toward her; She and the children's father are framed within the open door. Holiday greens adorn the stairwell and are connected to the exterior scene with color—note the bright green package under grandmother's arm and shutters on the home across the street. Briggs's story is expanded by other elements as well. Arms raised in greeting connect the young girl and her grandmother, and the cropped figure on the left, presumably the children's mother, tells us they are not home alone.

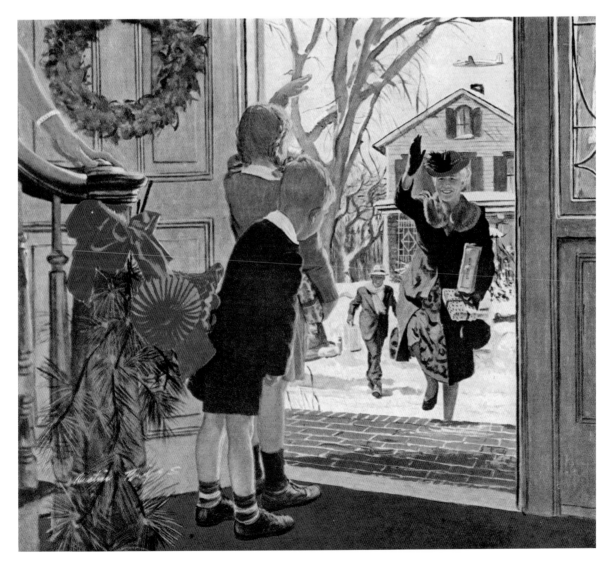

Austin Briggs
*Grandmother Arrives
for a Visit*, c. 1950
Illustration for American
Airlines: "I'm a lot closer
to my grandchildren . . .
holiday time or anytime."
Oil on Masonite

In telling a visual story, "the illustrator is presenting a play, and should instruct the actors not to overreact but to underplay their parts," wrote Ben Stahl. "In such a well-directed play, more can be expressed by a simple gesture on the part of a figure than by a wild, exaggerated motion trying to express the same thing." He advised artists to decide upon the mood of their story, choosing a situation to illustrate that gives a sense of the story as a whole. Then, "sift the action and props down to the essentials," composing these elements into a subtly integrated picture.

In his art, Robert Fawcett endeavored to "reproduce a moment of action. You must strive, by all the means at your command, to give the impression of movement, preceding and following the moment of action frozen in your picture."

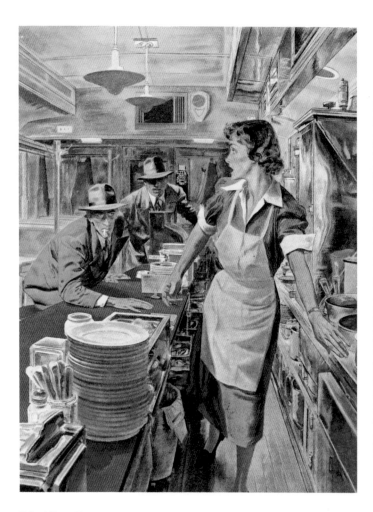

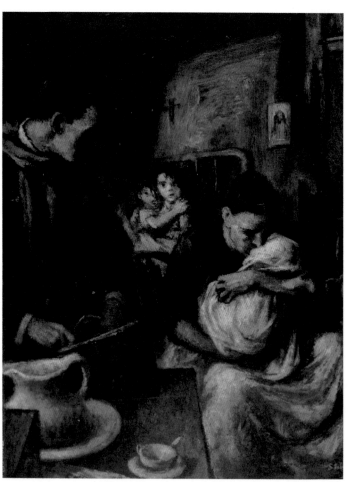

Robert Fawcett
Myra Whirled Suddenly. She Looked as If She Might Make a Break for It.
This illustration of a worried waitress striding away from two threatening figures conveys a sense of story through movement and emotion, which captivate the viewer. About to step out of the picture plane, the woman glances backward, directing us to the questionable characters propelling her to move away. Fawcett's painting takes a long view of the diner, employing vertical lines that establish pictorial depth. The counter, stove top, and the receding scale of the objects moving back into space, lead us directly into the action.

Ben Stahl
Come away from that infant, you damn fool. She had diphtheria.
Oil on board
This heartrending tale of a poor Pennsylvania mining family features a mother tenderly embracing her baby, who has died. "To me it called for a highly emotional and roughly painted treatment," said Stahl. The piece's somber tones underscore the dire nature of the situation, and Stahl purposely established an invisible line between the doctor and mother, a reflection of their psychological separation. Two frightened children appear in the background, underscoring the emotionality of the scene.

COMPOSITIONAL STRATEGIES

Exploring a Variety of Approaches

When Al Dorne got the assignment to create an illustration focused on an ailing farmer surrounded by his six lazy sons, he explored a number of picture strategies before settling on his final approach. He first envisioned the scraggly onlookers as vultures with outstretched necks observing their prey. In his second sketch, the farmer's sons mimicked the appearance of the birds. "As I studied the sketch," he said, "it no longer appeared very exciting to me. Despite the outstretched necks, the figures didn't seem to be doing anything in particular."

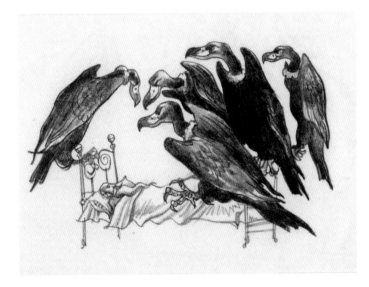

(*On this page and next*)
Al Dorne
Studies, *Six Greedy Loafers* by Frank O'Rourke
Collier's, June 27, 1955
Pencil on paper

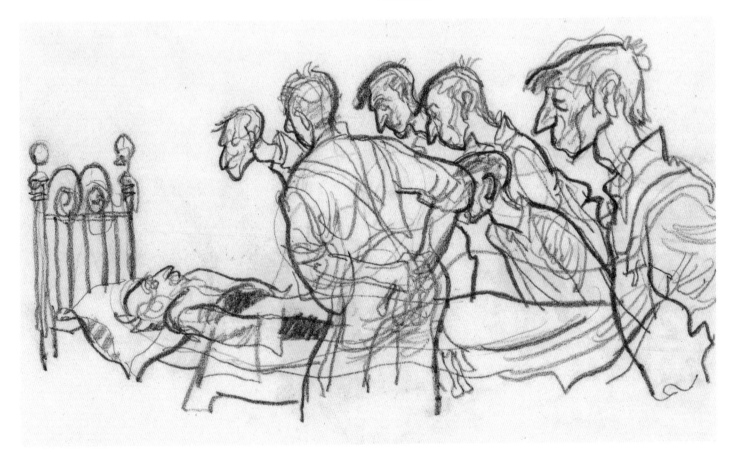

Imagining the sons as pallbearers at the side of their father's coffin, Dorne arranged them in a line with their backs to the viewer (below left). Ultimately, he found this approach to be static and instead experimented with a more active composition, in which the reclining figure could be better seen (below center). Note Dorne's directional arrows—both the farmer's sons and the cat bend toward him without blocking our view of his reclining form. The headboard, bottle, and bed sheets create a strong arrangement of stable horizontals and verticals and dynamic diagonals that help support the narrative.

Dorne finally took a more naturalistic approach by distributing his figures around the bed, as they might actually have arranged themselves in a three-dimensional space (below right and bottom left). He also added narrative details like a dresser and rug to his

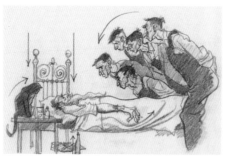
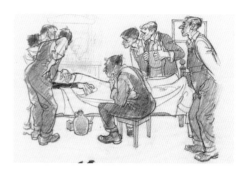

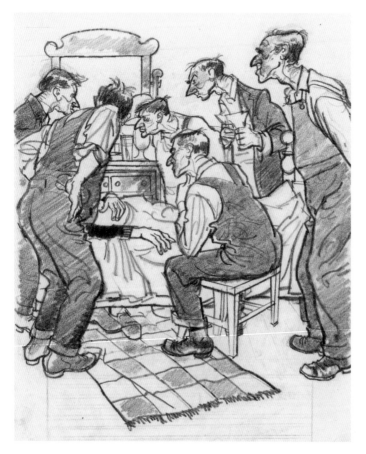
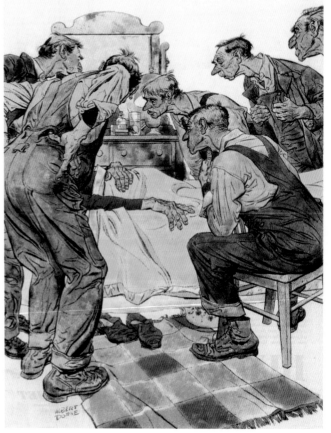

drawing, concluding that "this job teaches an important point. Choose an appropriate, effective symbol—here it was the vultures—and stay with it. Regardless of how much you rearrange or discard, never lose sight of the basic feeling or symbol you want to communicate." Color in his final illustration enlivens the scene, with a bright spot of red reserved for the main attraction.

Creating Visual Contrast

Stevan Dohanos's portrayal of a line of colorful mid-century cars aching to get around a Model T Ford is perhaps symbolic of an era in which traditional narrative illustration made way for more conceptual points of view. A sensitive portrayer of common objects and human interest stories, Dohanos employed visual contrast in this illustration—juxtaposing old and new vehicles to enrich his humorous tale.

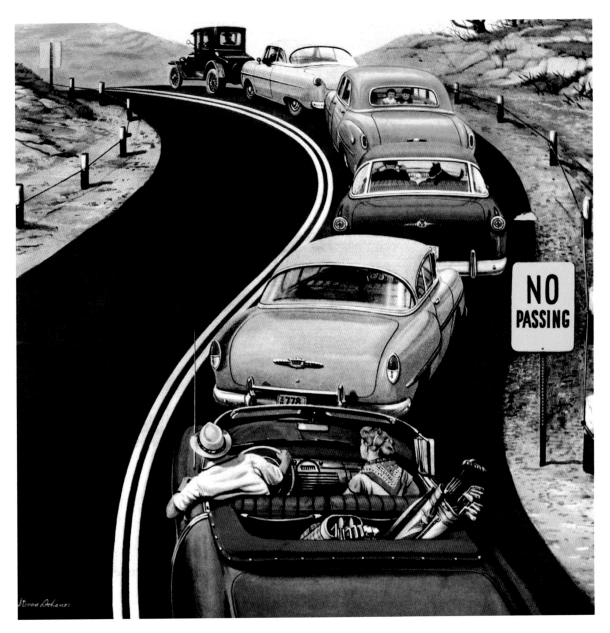

Stevan Dohanos
No Passing, 1954
Cover illustration for
The Saturday Evening Post, October 9, 1954
Oil on canvas

As with many of the Famous Artists, design and illustration go hand in hand in Dohanos's work. In *No Passing*, the winding road is set on an incline, which may have posed a challenge for the car leading the pack, underscoring his story concept.

Looking Beyond the Picture Plane

Rites of passage were popular themes for Norman Rockwell. Common ground for most people, they invited comparison with one's own memories. The subject of this painting seems an obvious one for Rockwell, who traveled often for assignments or pleasure and stayed at hotels frequently. *Just Married* presents us with a narrative that goes beyond the picture plane by referencing something that we cannot actually observe. In the artist's large-scale drawing—a significant step that came after the conceptualization of his idea, the selection of models and props, and the directorial creation of reference photography—we see only what remains of an unseen couple's honeymoon night. Affable hotel maids are left to celebrate vicariously, commiserating over a dust pan filled with confetti, a forgotten shoe, and a ribbon that defied Rockwell's intention to let pictures rather than words tell the story.

This technique was not always effective, even in the hands of an artist as skilled as Rockwell. Intended as a cover for *The Saturday Evening Post* but never published, *War News* pictures a restaurant counterman and his customers, including a Western Union agent, a clerk, and a deliveryman, gathering to listen to a radio report. Focused on the proposed invasion of Normandy, Rockwell's painting features a newspaper headline from January 17, 1944, *Troy Times Record*, which reads, "Invasion Plans At France Possible." Rockwell decided not to submit *War News* to the *Post*, perhaps because it was hard to convey what the men were hearing or to make the newspaper headline discernible. He instead went on to create a second painting of a man charting war maneuvers.

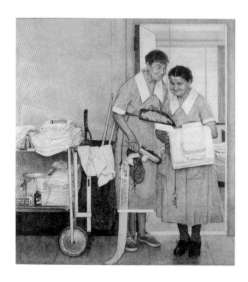

Norman Rockwell
(*Above*) Study for *Just Married*
(*Morning After the Wedding*), 1957
Cover illustration for *The Saturday Evening Post*,
June 29, 1957
Charcoal and graphite on paper

(*Right*) *War News*, 1944
Unpublished
Oil on canvas

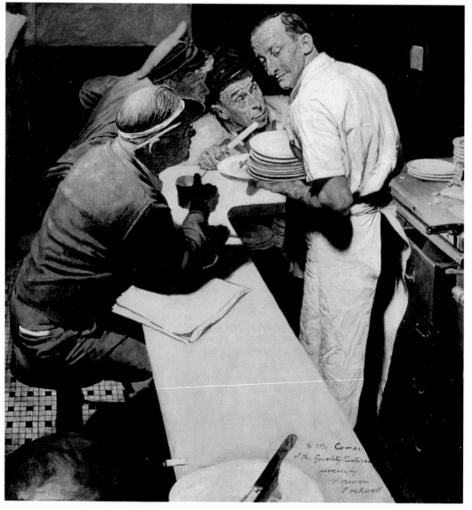

Making Subtle Adjustments

As Austin Briggs demonstrates, subtle differences in a visual narrative can shift its feeling or meaning. In his first drawing of a father and daughter traveling on a train, the man is fast asleep and unaware of his child's desire to wake him. However, in the second piece, Briggs adjusts the father's body language and demeanor slightly to create a sense of warmth and connectedness between the two. No longer isolated, he smiles as he is roused from sleep.

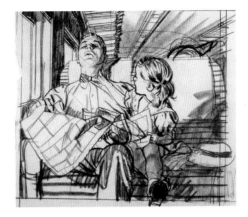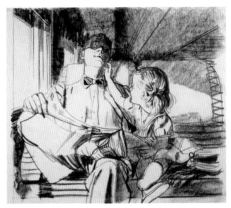

Austin Briggs *Father and Daughter on Train*. Advertisement for New York Central Railroad. Graphite on paper

NOW YOU TRY IT!

REIMAGINING AN ARTWORK

Choose one of the illustrations at right or another drawing, photograph, or illustration from this book to use as a jumping-off point.

- What story does it tell?
- How might its narrative be expanded or changed by adding details, subtle or dramatic?
- Create a new piece, inspired by the original, that carries a different meaning or story.

(Clockwise from top left)
Norman Rockwell
Checkers, 1928
Oil on canvas

Peter Helck
Hollowed Tree Trunk
Pencil on paper

Harold von Schmidt
Charlie V-4, 1929
Oil on canvas

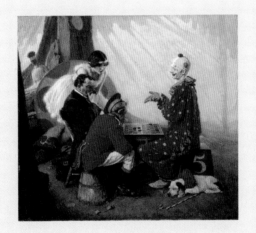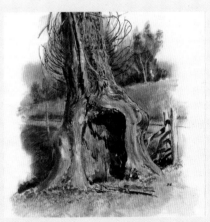

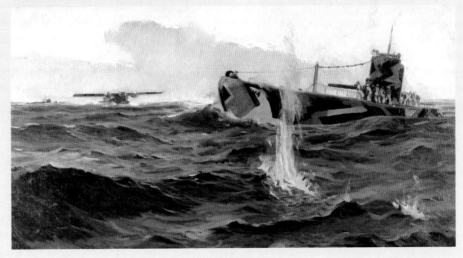

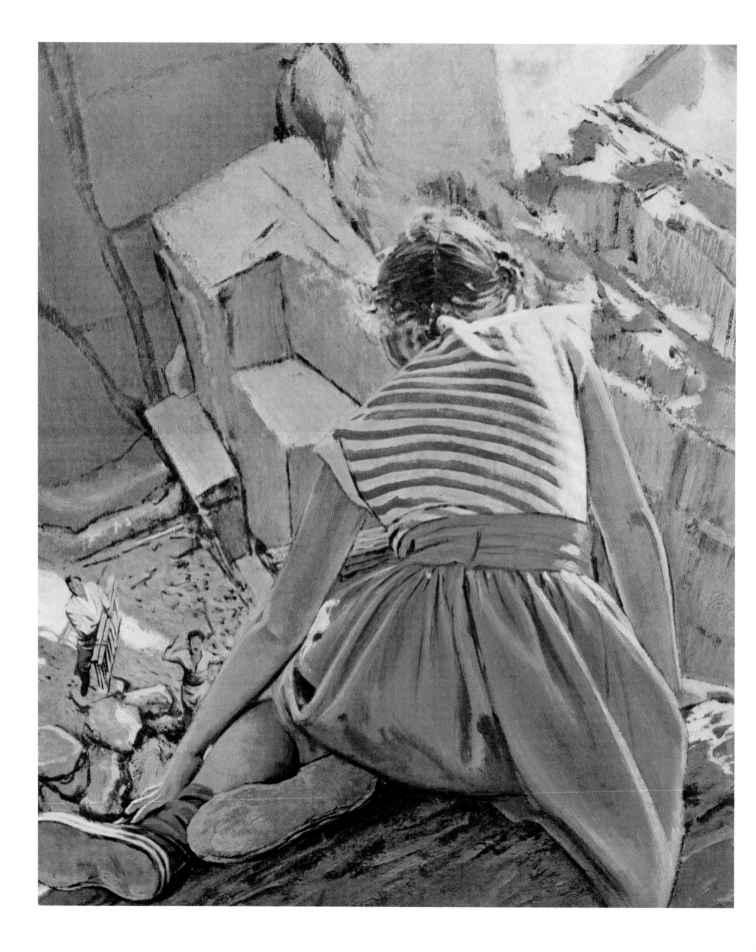

2 MAKING IT PERSONAL

The creators of the Famous Artists School courses were in complete accord on one principle—artists should live life fully in order to have experiences to draw from in creating their art. "The illustrator must not only master his craft but must live, pile up experiences, and become aware of the infinite aspects of our world," said Austin Briggs. "He must distill everything into a sensitivity to create characters and situations that communicate to viewers; he must communicate a mood he has felt and express his enthusiasm for his characters and situations."

In this illustration (opposite), Austin Briggs literally places us at the edge of a cliff, looking over the shoulder of a young girl whose parents below are understandably distraught. He invites us to experience her plight firsthand and draws upon our own understanding of the potentially dire nature of the situation to inspire engagement with the image and narrative.

Austin Briggs
Illustration for
The Innocent Daredevils
by Stephen Cole
The Saturday Evening Post,
March 11, 1950

INFUSING YOURSELF INTO YOUR DRAWINGS

Much in Rockwell's art is inspired by autobiography. "I once did a cover showing a father seeing his son off to college," he wrote, referring to *Breaking Home Ties*, a cover illustration for the *Saturday Evening Post*. "That year my three boys had gone away and I'd had an empty feeling—it took me a while to adjust without them. This poignancy was what I wanted to get across in the picture. But there was humor in it too," Rockwell reflected. "I put a funny kind of suit on the boy because he was a ranch boy leaving home for the first time. And his father was holding two hats, one the boy's beat-up old rancher's hat and the other his brand-new hat. The boy was carrying a lunch box all done up in a pink ribbon. I drew a collie dog with his head on the boy's lap. I got most of my fan letters about the dog. You see the father couldn't show how he felt about the boy's leaving. The dog did."

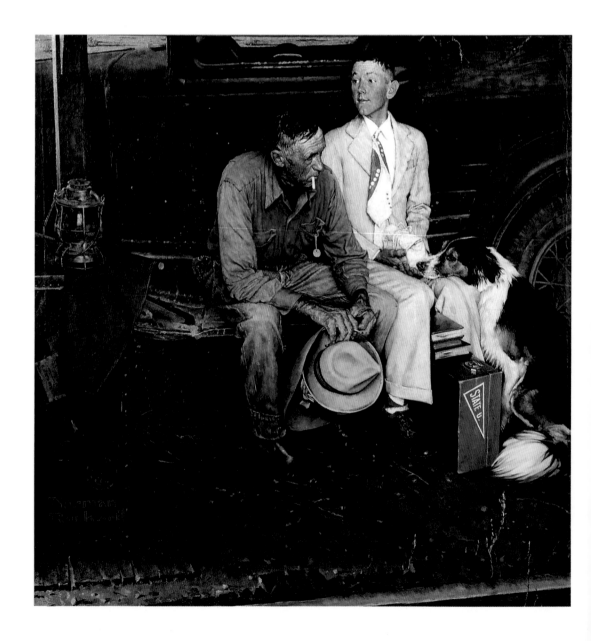

Norman Rockwell
Breaking Home Ties, 1954
Cover illustration for
The Saturday Evening Post,
September 25, 1954
Oil on canvas

John Atherton was an outdoorsman and an avid fisherman, and his choice of subject matter often reflected these passions. This quick sketch, a self-portrait, was created to furnish details for a painting that he planned to pursue later on. A close friend of Atherton's, Rockwell sometimes joined his fellow illustrator on fishing excursions. Though Rockwell enjoyed the companionship, his take on the experience was somewhat different, as portrayed in his 1939 *Saturday Evening Post* cover, *Sport*. As with Atherton and Rockwell, your interests and challenges can both be viable jumping-off points for your art.

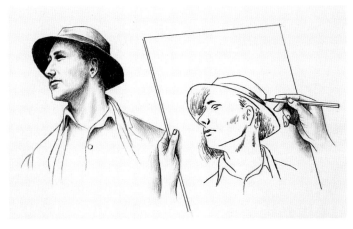

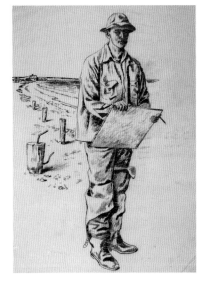

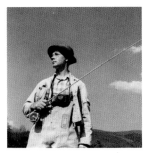

John Atherton
Self-Portraits as Fisherman,
c. 1948
Pencil on paper

Photograph of the artist with fishing gear

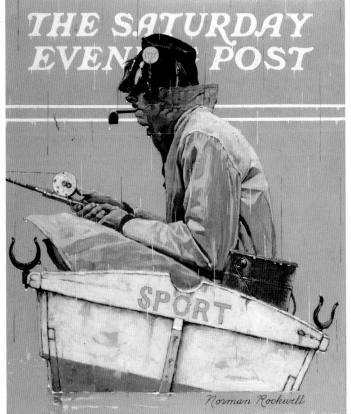

Norman Rockwell
Sport, 1939
Cover illustration for *The Saturday Evening Post*, April 29, 1939
Oil on canvas

Sport describes Rockwell's feelings about the sport of fishing. Uncomfortable, cold, and wet, one's pipe does not stay lit and bailing out the boat is inevitable. The absence of oars adds to the viewers' discomfort level and leaves us to ponder more possibilities. Not missing any opportunity to communicate the feeling of wetness, Rockwell paints *The Saturday Evening Post*'s masthead letters to appear as if they are dissolving in the rain and droplets are added to the subject's fishing line, chin, and nose. Although the overall mood is one of gloom, the repetition of color accents adds interest. Teal, an often-used color, is repeated on the boat bottom and the shade tone of the man's yellow slicker, and vermilion accents the bucket, shirtsleeves, fishing rod, and flies. The blush of the fisherman's cheek tells us it's not only wet—it's also cold.

Time and again, Famous Artists School masters urged their students to go out and steep themselves in art and experiences. For Robert Fawcett, other training was just mechanical. He said not to worry about technique or about developing a style—your technique will come from your way of thinking and feeling and your style will follow naturally. Drawing on location frees the mind and the hand, making possible personal exploration with no strings attached—as illustrated by Fawcett's observational sketchbook page created in Newtown, Connecticut.

Al Dorne's approach was quite different from most of his fellow artists. He was famous for working at lightning speed, and he rarely used models or took reference photographs. However, he read voluminously and had a powerful visual memory, and his own life experiences revealed themselves in the way he used small details to evoke character. He drew on the world around him as a keen observer of the human condition. This drawing of a man sitting by a bar, with a wrinkled trouser leg and a quizzical expression, is a perfect example. Dorne also focused on body language, character types, and personal interactions in a scene featuring a lively group of coffee drinkers.

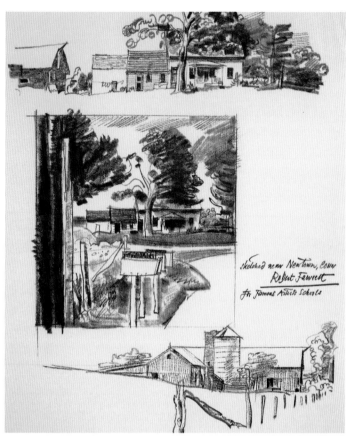

Robert Fawcett
Sketches of Newtown, Connecticut, c. 1948
Pencil on paper

NOW YOU TRY IT!

CAPTURING THE SCENE

Pick up your sketchbook and carry it wherever you go for a week.

- Stop to draw something that captures your attention at least twice each day. Sketches need not be detailed; they should just capture the essence of each scenario.
- At the end of the week, choose the drawing that you feel is the most compelling for its composition, subject matter, or visual impact.
- Use that seed of an idea to create a new artwork inspired by the sketchbook drawing that you selected.
- You can expand your drawing's storytelling potential, enhance its detail, or adjust its compositional arrangement to increase impact.

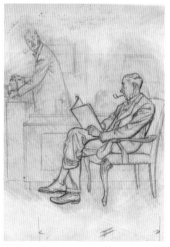

Al Dorne
Studies, *Group Drinking Coffee* (left) and *Man at Bar Reading Newspaper*

DRAWING UPON THE WORLD AROUND YOU

Let's consider what makes artists like Michelangelo, Rembrandt, or Picasso great. Why is their work memorable? Here's one explanation: They had a unique way of looking at things and a particularly effective way of expressing and communicating feeling and emotion. As the founding illustrators all agreed, artists must train themselves to see and observe more closely and attentively than other people.

Austin Briggs made the sketches shown below on a trip to Charleston, South Carolina. He wrote, "They started out to be objective and factual, but in some ways they became sort of fanciful. I can't stick to the factual long without personal reactions setting in and changing the objective facts. I'd probably be a very poor reporting artist. Some of the material shown here will probably turn up in a painting sooner or later. My pictures are based on my own experience, and these sketches are aspects of that experience."

Briggs went on to counsel, "Don't worry about *how* to draw. Rather, express what you see, interpreted by your eyes and brain. Reduce it to its essentials. If you can successfully transmit the essence of what you see, you will succeed in expressing something new and completely personal, not only a record of what you see but an expression of *you*—and therefore unique."

Austin Briggs
Studies of Charleston,
South Carolina
Ink on paper

Harold von Schmidt reminded artists that we each experience things as if for the first time, even though they have happened to others before. Illustrating the truth, as you know it, will give your art a unique sense of believability.

Robert Fawcett was a great believer in the value of sketching, sketching, and more sketching. He always had a notebook at hand and filled it at every opportunity with drawings of whatever he saw around him. He wrote, "This kind of work should go on constantly around the home and outside to supplement serious finished studies." The advantages of the "sketching habit" are twofold: the hand becomes practiced at rendering and the eye learns how to observe.

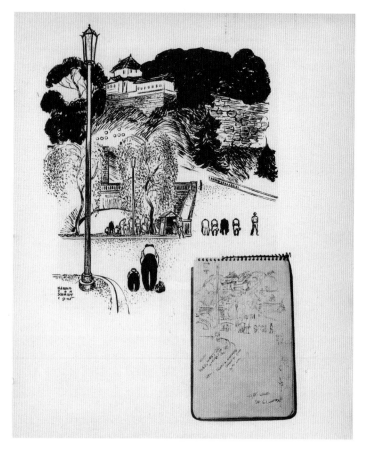

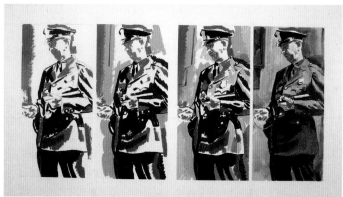

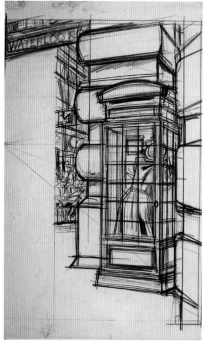

Robert Fawcett
Sketches, *Police officer* (*above*) and *Woman in phone booth*
Pencil and ink on paper

Robert Fawcett's sketches capture essential information, from the natural gesture and silhouette of a figure to geometric architectural elements and their settings. The artist's progressive study of a policeman begins with loose gestural work that emphasizes shape, light, and shadow. Note how he gradually refines his work by adding detail and refining tone—the policeman's face, hands, and badge are emphasized as the lightest elements in the picture.

Harold von Schmidt
Japan sketchbook and drawing, 1945
Ink on paper

These are sketches of Tokyo from von Schmidt's notebook; the drawings he made from them have an unmistakable authenticity. He wrote, "Your illustrations can be enriched by what you do, think, feel, and know. The challenge is to use your knowledge well."

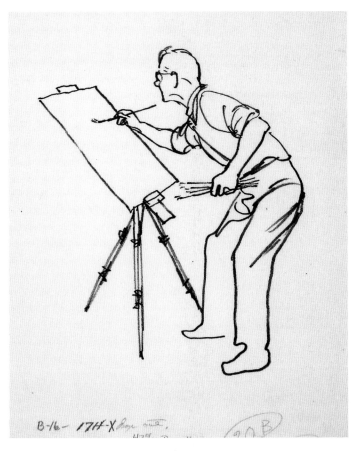

Austin Briggs
Sketches of man painting at an easel and woman dressed in bathing suit and overcoat
Ink on paper

These sketches by Austin Briggs are perfect examples of the observant eye at work. Few details have been included, but the shapes of his subjects' bodies, and their postures and attitudes, have all been effectively captured. Drawings such as these could serve as reference for a finished work or simply as yet another exercise in training the artist's eye.

NOW YOU TRY IT!

THE QUICK GESTURAL STUDY

Here, you'll use your sketchbook for quick gestural studies.

- In your sketchbook, create several quick gestural studies each day for a week by observing the people around you.
- Focus on their movement and postures rather than the details of their appearance.
- Use loose, flowing strokes to capture figures in motion or at rest, whether on a train or bus, at a sporting event, or at work or school.

You will quickly become attuned to the subtleties of body language, which add interest, depth, and meaning to your art.

GATHERING INSPIRATION

Inspiration is drawn from many sources—from memory and firsthand experiences to imagery in print or online. Thorough research is the underpinning of many compositions, especially if you are striving for a sense of realism and accuracy. But another kind of research is essential, too: experience derived directly from the object, scene, or situation—to live the experience yourself. Seeing prompts a reaction, which is what artists want to communicate. They see things in a personal way, and their paintings should invite viewers to see them just as personally through their own perceptions.

Fred Ludekens notes that "the significance of what an artist sees, or how much or how little he wishes to show, is his prerogative. This is where lies originality, concept, force, dramatics, interpretation and all the other things that build original attention-getting pictures. The picture becomes a product of you—the control being entirely in the artist's hands."

Between assignments, Fred Ludekens found it productive to do what he called "informative sketching." He wrote, "*Essential information* is my chief concern in sketching. These 'sketches' are really informative diagrams. I do them just as fast as I can, with little concern for academic drawing. I write notes to myself all over the page. With observation, memory, diagrammatic sketches, and a reference file I seem to have what I need for my way of working."

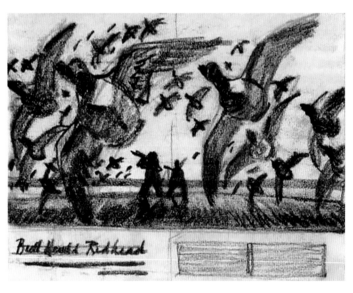

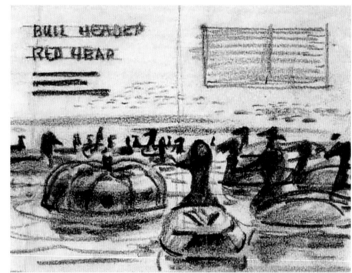

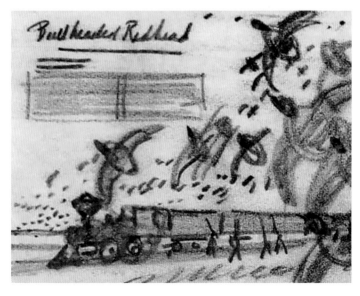

Fred Ludekens
Studies for "They Should All Be as Stupid as Redheads" (working title, "Bull Headed Redheads") by Hart Stilwell, *True* magazine, November 1950

"I have found most people I work for are interested in how I think," Ludekens said. In these three layouts for a double-page magazine spread, he offers three perspectives derived from his own observations, each numbered to indicate his preference. Image number one, the artist's favorite, is set against a low horizon line. In this study, geese are flying "like hell" to escape the hunters in the center middle ground, creating dramatic impact.

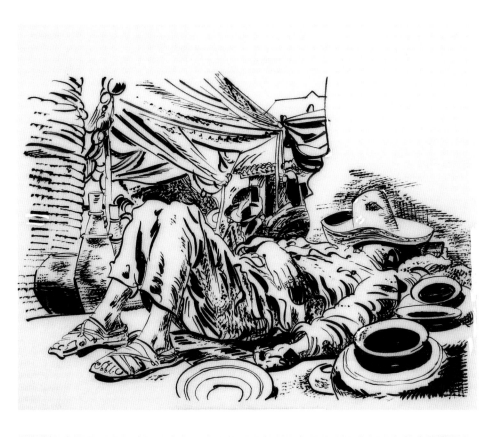

Robert Fawcett
Character study
Pencil and ink on paper

In addition to referring back to his sketchbooks for material for his finished illustrations. Fawcett was also a proponent of yet another way to "make it personal": He often posed for the photos on which he based his illustrations. He wrote, "I posed myself, as I invariably do, because then I could feel the pose. Looking at a posed model, I might have been able to see a lot of interesting things, but to feel the action by doing it myself—that is the way I work best." This illustration was meant to convey "the essence of recumbency," lassitude in a tropical climate.

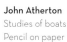

John Atherton
Studies of boats
Pencil on paper

John Atherton sketched these boats as a recording of facts to be used in a painting. He wrote, "The approach was direct and the textures were made with longer, straighter strokes than I frequently use. The tones are blacker as well and the whole effect stronger. The effect of the light was necessary, and its general direction, so the shadows are more factual than decorative."

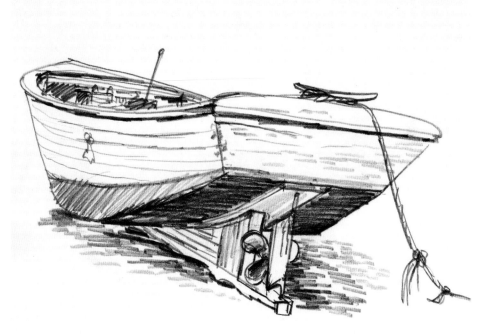

THE IMPORTANCE OF EMPATHY

Empathy, or the ability to feel with the characters and the action you are portraying, is the secret to making your pictures come alive. The spirit of the event, according to Austin Briggs, is more important than the fact. Paint what moves you; present your emotions so that your viewer can share them.

Exploring a similar theme, Norman Rockwell's *Girl at Mirror*, a 1954 *Saturday Evening Post* cover illustration, pictures a child's transition to young adulthood. Rockwell had a natural ability to portray experiences that a broad audience could easily relate to, an essential element of his success.

Girl at Mirror follows a long tradition of artists who have pictured a woman contemplating her reflection. George Hughes, fellow *Post* cover artist, said that Édouard Manet's 1877 *Woman Before Mirror* inspired this painting. Two paintings by other artists stand out as strong candidates, however. Included in Rockwell's reference files are examples of Picasso's *Girl Before a Mirror* and Louise Élisabeth Vigée Le Brun's *The Artist's Daughter*, each of which could have directly influenced this work. Rockwell typically created a full-scale charcoal drawing in preparation for work on his final canvas. The drawing closely resembles his finished illustration, from the main

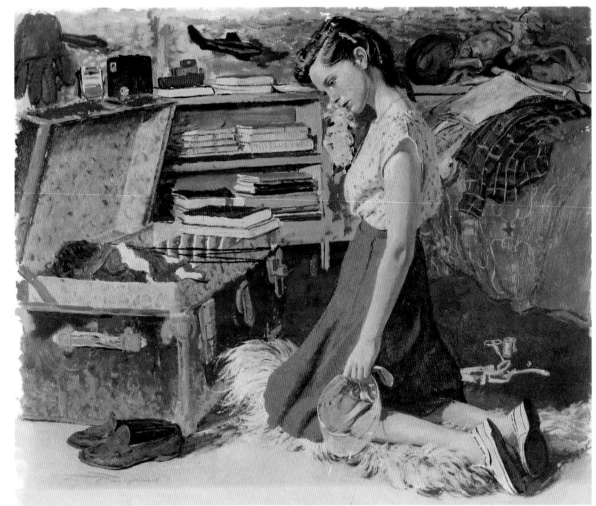

Austin Briggs
I'll Never Let You Go, 1948
Illustration for
The American Magazine,
1948
Casein on board

In this story illustration, Briggs inspires empathy for this young woman, who explores the depths of memory through the objects found in a storage trunk.

picture elements to the appearance of actress Jane Russell on the magazine pages. There are, however, distinct differences between the two. Consider the changes that Rockwell made in his final and what impact they have had on the painting.

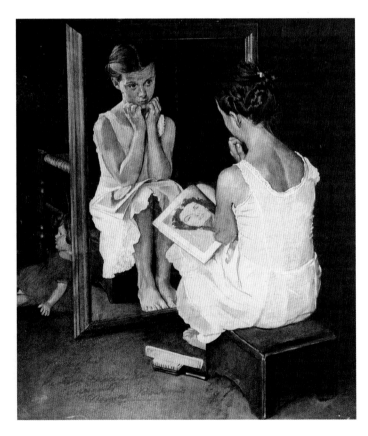

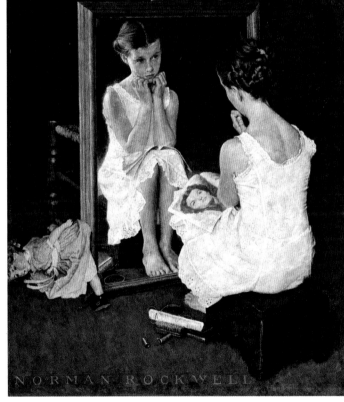

Norman Rockwell
Girl at Mirror, 1954
Study (in charcoal) and final cover illustration
The Saturday Evening Post, March 6, 1954
Oil on canvas

Al Parker was especially good at creating innovatively designed scenes that felt alive and real to his viewers. In these preliminary drawings for one of his mother-and-daughter illustrations, he first works out his composition in terms of large shapes and movement lines. When he begins to add detail to the faces and clothing, we see the personalities of the characters and the relationship between them emerge.

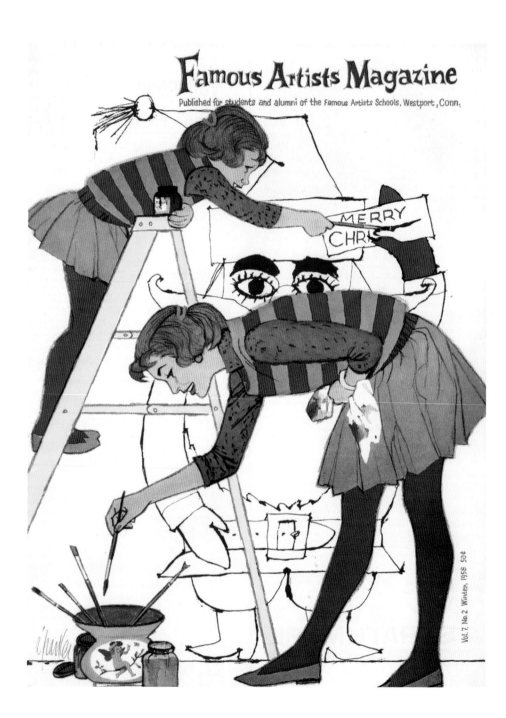

(*All images on this spread*)
Alfred Charles Parker
Pencil studies for and final cover illustration
Famous Artists Magazine, 1958

Tell Me the Time, 1946
by Marie Fried Rodell
The Ladies' Home Journal, November 1946
Gouache on board

This story illustration presents a situation that Parker had probably not encountered in his own experience. An air of mystery fills this work, which accompanied the dramatic tale of a young woman who, locked in her apartment without a telephone or a clock to tell the time, is kept from discovering a gruesome crime. Parker's skewed composition, replete with the model's tension-filled pose and the dizzying distortion of the room around her, contributes to a feeling of unrest and worried anticipation. Not only her eyes but her whole bearing warns us that something dramatic is about to happen.

There's nothing like it on Earth for traveling with a baby!
Illustration for American Airlines advertisement

In this piece, the connection between mother and baby is so intense as to almost make us forget what the illustration is advertising! A father and professional observer, Parker had likely absorbed a number of similar scenes and so was able to effectively recall and re-create the emotional content. Interestingly, he added the movement of the man turning a page in the background to give action to what could have been a static scene. Somehow, that small gesture adds even more life to the image.

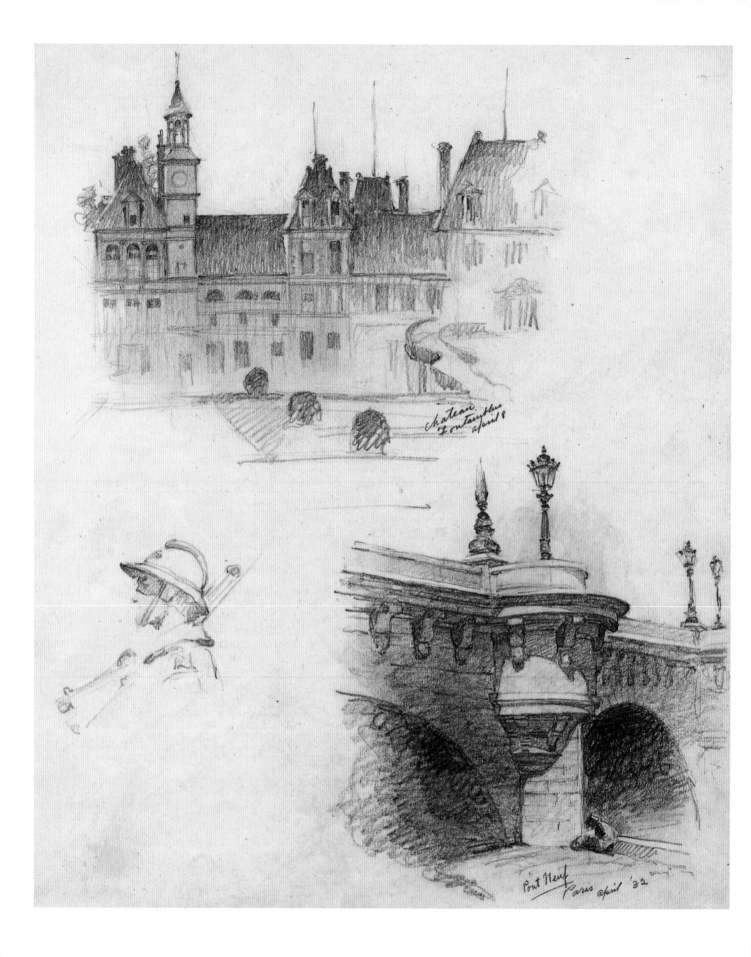

Chateau
Fontainebleau
april 8

Pont Neuf
Paris april '32

3 DRAWING AS A TOOL FOR SEEING

For each of the Famous Artists, drawing was a tool for seeing—an integral aspect of artistic expression that allowed them to formulate and capture the fleeting essence of ideas and refine picture concepts. As we'll see in this chapter, creative approaches to drawing let the mind roam free and help ideas take shape.

Norman Rockwell rarely had time to sketch uninterruptedly unless he was traveling—an activity that refreshed him and took him away from the deadlines of a busy illustration practice. He traveled extensively throughout his life for both business and pleasure. This rare sketchbook page documents the artist's travels to France in 1932, where he recorded the architectural details of the historic Pont Neuf, the oldest standing bridge across the Seine River in Paris.

Norman Rockwell
Sketchbook drawings, 1932
Pencil on paper

THE IMPORTANCE OF DOODLING

Robert Fawcett spoke for his fellow master artists when he wrote, "Spend every spare moment developing the coordination of your eye and your hand to acquire greater resources for what is a difficult business at best. Do not be content with a few sketches. Make hundreds, thousands of complete studies, action sketches, composition notes and accurate observations of the visible world all around you. This will train your brain to remember and your eye to be observant.

Draw constantly, freely, searchingly, courageously, experimentally, lovingly. Forever draw because what you put down is the measure of what you have seen. The more you draw, the more you will *see*." In these pages shown below from his sketchbooks, we can see what Fawcett meant.

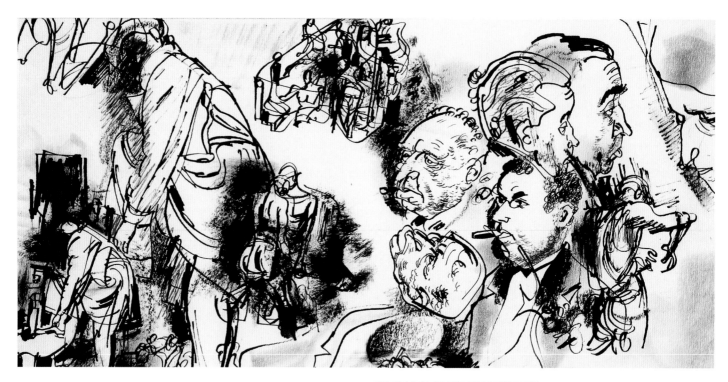

Robert Fawcett
Sketches
Ink and pencil on paper

According to Fawcett, drawing over and over gives you knowledge of form, an accurate eye, and an obedient hand. Once you have those, you can forget technique and a focus on accuracy and concentrate on what it is you're trying to communicate. These drawings show Fawcett searching out the small details that reveal character and re-creating them in line.

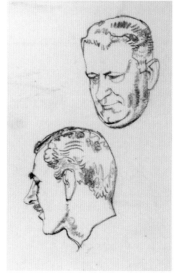

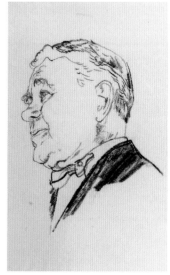

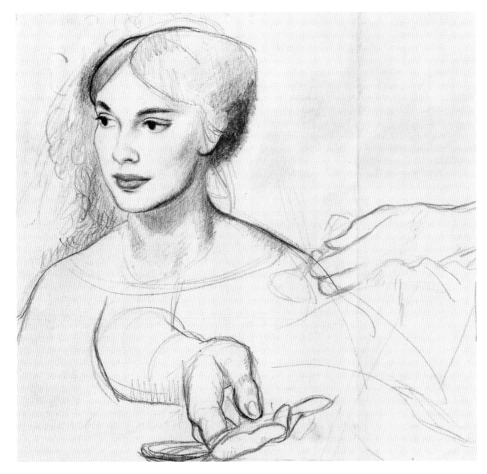

Ben Stahl
Sketches
Pencil on paper

Ben Stahl's advice was specific—he recommended sketching every day. "Your drawings may be only doodles, but they will free your imagination if you practice constantly." In his sketches, Stahl sometimes focuses on specific elements, such as facial expression or the movement and position of hands. At other times, his rough drawings block out the underpinnings of a composition with simple lines and tones.

John Atherton
Sketches
Pencil on paper

John Atherton took doodling a step further. He recommended doing five-minute sketches as practice for more developed drawings—these quick sketches of boats were designed to record facts that he would use in a larger piece. Minor alterations from the first drawing (*near right*) to the second, such as the streamlined arrangement of rowboats and the addition of a distant hill, have substantial visual impact.

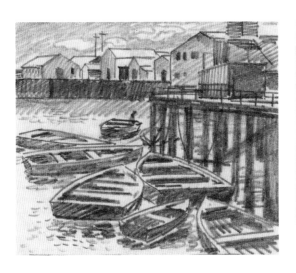

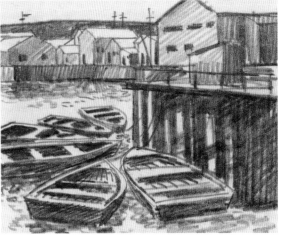

Fred Ludekens agreed with Ben Stahl: "If you learn to draw well (learn the structure and function of humans and the shapes of inanimate objects), it will give you a language and vocabulary for meeting any artistic challenge." The small but striking studies below, created in a variety of media—from ink to pencil and colored pencil—are designed to hone his vision by capturing information about the world around him quickly and spontaneously.

(*All images on this page*)
Fred Ludekens
Sketches
Mixed media on paper

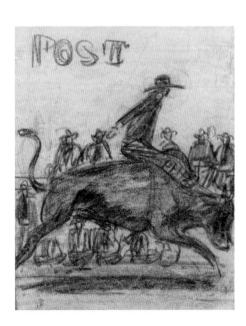
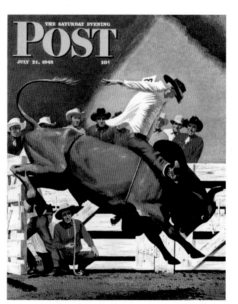

Study and final illustration for *Bull Rider*, 1945
Cover illustration for *The Saturday Evening Post*, July 21, 1945
Study, pencil and colored pencil on tracing paper
Final, gouache on board

In the thumbnail sketch of a bull-riding cowboy, Ludekens captures important storytelling and compositional details for his *Saturday Evening Post* cover. His final painting adjusts the bull's posture to emphasize action and uses the color red in his background figures rather than on the cowboy himself, as indicated in his sketch.

Haste makes Waste

Do not squander time for that's what life is made of

(*All images on this page*)
Norman Rockwell
(*Left*) Illustrations for *Poor Richard's Almanac* by Benjamin Franklin, 1963
Heritage Press, Inc.
Pen and ink on paper

In these drawings, the artist's line takes on a vibrant, autographic quality that conveys each of the book's wise sayings with good-natured humor and a sense of theatricality.

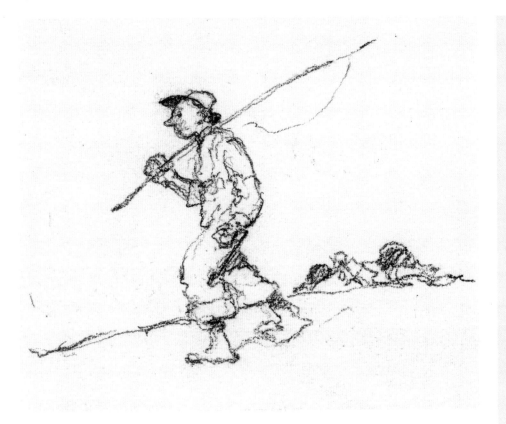

Sketch
Pencil on paper

Rockwell often began his artistic process by making small sketches, or thumbnails, that expressed the kernel of an idea purely from his imagination. This quick sketch of a fisherman captures the essence of his subject's posture, demeanor, and lanky gait with little more than a few simple strokes.

NOW YOU TRY IT!

—

LET AN OBJECT TELL A STORY

Norman Rockwell advocated a stream-of-consciousness approach to doodling, which inspired fresh ideas. He described starting with a quick drawing of a random object, saying, "I must start somewhere and if I did not start with the lamp post or something else, I would spend the day looking at the blank paper." The lamp post led Rockwell to consider who might be leaning against it and what his or her backstory might be, and his ideas blossomed from there.

- In the center of your paper, draw a simple object from life or from your imagination—whether a teapot, a toothbrush, your sleeping pet, or anything that captures your interest.
- Respond spontaneously to your initial sketch by including other related things in your drawing that might prompt an idea for a more developed picture.

In addition to giving your eye and hand a thorough training in seeing and recording, sketching can be used as part of your research for future projects. The page below from Austin Briggs's sketchbooks shows one way to do "informative sketching," which can function like notes jotted on the spur of the moment. Because of this habit of sketching constantly and in many different situations, Briggs had a wellspring of images to call on, no matter what the subject matter of his next assignment might be.

Whenever he could, Peter Helck made a point of actually spending time in a setting that he would incorporate into an illustration. For example, to research the backgrounds for an assignment featuring trains in the Hudson Valley, he used a motorized handcar to travel the rails for a day, sketching as he went. To him, "that day's work in the sun and wind, being passed by the Empire State Express at 80 miles an hour in a flurry of grit and hot steam, and clattering between the dank, cavernous rocks at Garrison where the sun never shines—these sensations . . . constituted research of the finest sort."

Austin Briggs
Sketch
Ink on paper

Briggs sketched this restaurant interior, which to him had a European feel, to serve as reference for a setting in some future story illustration. Briggs wrote, "A fundamental of my approach is to bring as much as possible of my own experience to every job that I do."

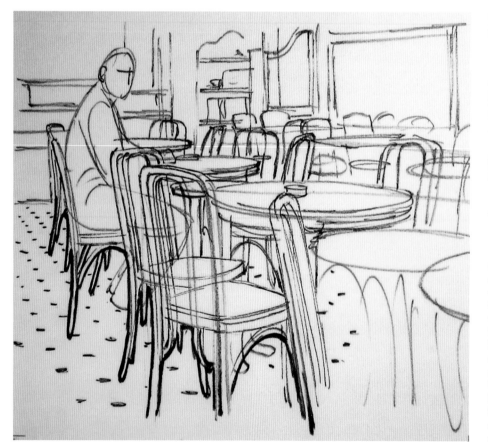

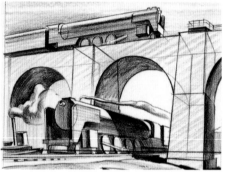

Peter Helck
Sketches
Ink on paper

In these on-location sketches, Helck used his exacting powers of observation to record small, significant details for future use, even making hand notes to underscore important information. He counseled his students to "get in the habit of noticing the elements that catch your attention in a scene, then use those elements, in that position or lighting, to build your composition." In Helck's work, drama was achieved by the effective use of verticals, horizontals, and diagonals. In this preliminary sketch for a painting of two locomotives traveling in different directions, he was aiming for a feeling of vitality and excitement, achieved by having them cross at right angles. The impression of speed was augmented by the way Helck drew the tilting, elliptical shapes of the lower engine's wheels.

In the mid-1950s, Rockwell traveled around the world on assignment for Pan American Airlines, for an ad campaign that brought him to cities in thirteen countries—from England, France, and Italy to Lebanon, Turkey, Pakistan, Thailand, and Japan, which were Pan Am hubs. His goal was to capture the local color and character of each location in spontaneous sketches focusing on people and places in a random arrangement of elements on his page.

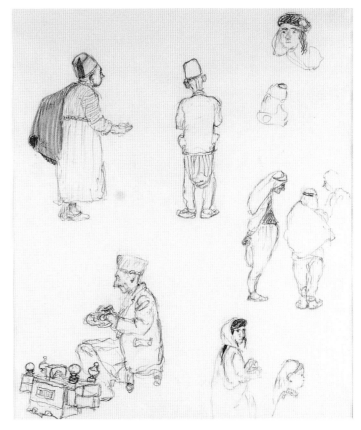

Norman Rockwell
Sketchbook drawings for
Pan American Airlines, 1955
Clockwise (*from top*):
Turkey, Japan, and England
Pencil on paper

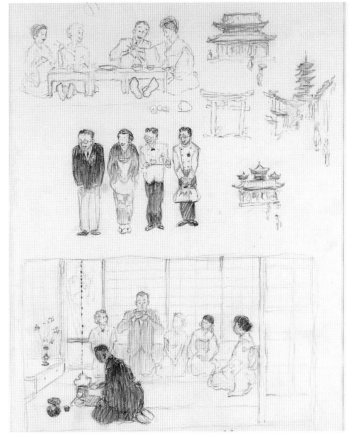

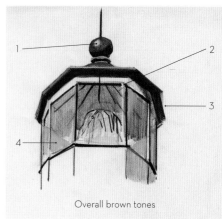

Overall brown tones

(Clockwise from top)
1. Blue
2. White rails
3. Linen cover
4. Blue sky

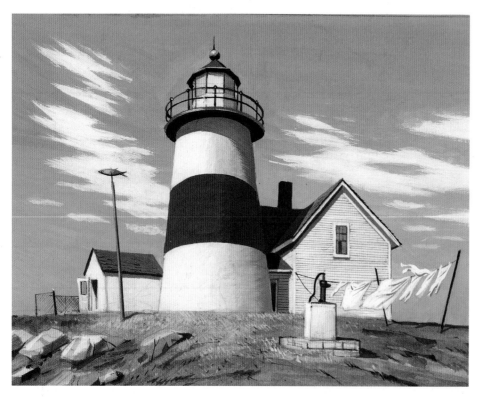

Stevan Dohanos
Lighthouse studies and painting
Study, pencil on paper; final, gouache on board

Dohanos began this painting with a rough sketch of the lighthouse and its surroundings. As he began to develop the details, he made additional sketches of different elements of his composition, adding spots of color as a kind of mnemonic to remind himself of what he had noticed in his on-location sketching.

NOW YOU TRY IT!

CREATING "SNAPSHOTS"

Create quick sketches of the world around you by making four different drawings inspired by the same location. Note your observations about color, mood, and detail on your page, as Stevan Dohanos did.

- Sketch an inanimate object, such as a car, an appliance, or a utensil.
- Sketch a living thing, such as a person, an animal, or a type of foliage.
- Sketch the broad sweep of your environment in simple strokes to capture the scene.
- Consider which drawing might lend itself to further development and take it to the next level.

Sometimes, the information being gathered through sketching has less to do with factual knowledge and more to do with composition—or, as Robert Fawcett preferred to call it, "picture organization." In the first sketch, Fawcett arranged the figures so that they are related, with focus on their individualized body language. There seems to be a story in their gathering. In the second version, the figures are subtly altered in posture and scale. He explores areas of overlap and light and shadow. In the third drawing, he places his figures in a structural setting filled with geometric forms. Finally, he begins to work out the subtleties of expression, body language, and interior detail.

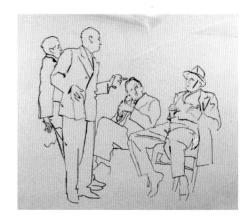

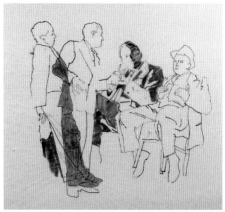

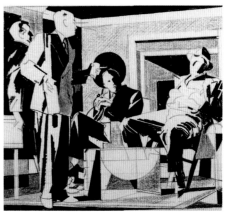

Robert Fawcett
Sketches and studies of men in conversation
Pencil and colored pencil on paper

SKETCHING FOR GREATER CLARITY

Norman Rockwell's rough preliminary sketches were the first depictions of his ideas. He began each modeling session by showing his thumbnails to his models and describing the concept for his new illustration. Then, he would strike the poses himself and enthusiastically act out each part to demonstrate what he wanted, getting his performers into the spirit. The camera was also an integral part of his process, as it captured the nuances of expression and the difficult-to-maintain positions that he coaxed from his models.

In *New Television Antenna*, Rockwell measures the promise of new technology against the historical past, and invites our consideration of whether television may become the "religion" of the future, as suggested by the church steeple. The artist's conceptual drawings increase in detail as his idea for this 1949 *Saturday Evening Post* cover crystallizes.

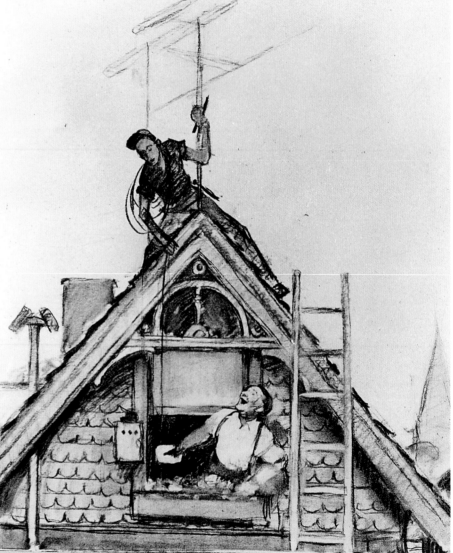

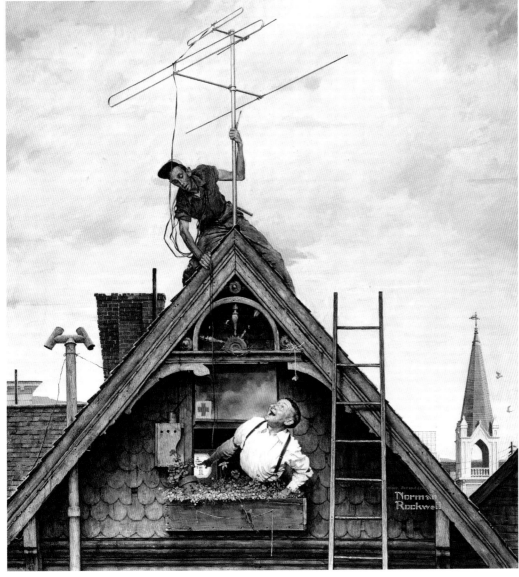

(*All images on this spread*)
Norman Rockwell
Sketches, photographic studies,
and final illustration for
New Television Antenna, 1949
Cover for
The Saturday Evening Post,
November 5, 1949
Final, oil on canvas

Notice Fred Ludekens's rough sketch for *Renegade Canyon* on this page of studies. Although the background has a more vertical orientation, the composition is closely aligned with his final illustration. In his sketch of a cowboy on horseback holding a woman in distress, Ludekens made sure that "the man's arm comes forward and clearly goes under the woman's arm," and that a rhythmic, flowing line enveloped both figures. Informal thumbnail drawings allow the artist to consider the possibilities of a composition's vantage point, narrative, and perspective.

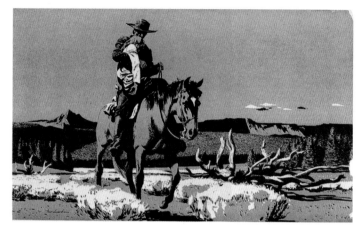

Fred Ludekens
Studies and final illustration for *Renegade Canyon* by Peter Dawson
The Saturday Evening Post, 1949

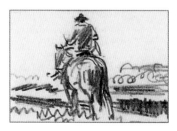

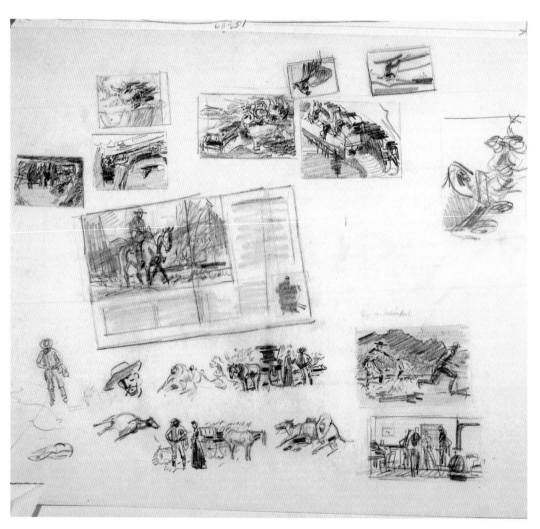

THE CONSTRUCTION OF FORM

According to Robert Fawcett, drawing the same thing over and over again enhances an artist's knowledge of form and sharpens focus on detail. This allows the artist to forget "technique" and concentrate on structure. The three interpretations of an identical man, below, seen from the rear holding a shovel, examine the figure's stance and silhouette, and explore the effects of light and shadow on form. First, Fawcett created a simple contour drawing and filled it with flat tones. His second drawing employs line and stark shadows to delineate form, and his final work relies upon line, shadow, and varied tone to create a more complete picture.

The quick portrait studies at right, which Fawcett frequently made, rely on light and shadow to create volume, and search out the small details that reveal character and emotion.

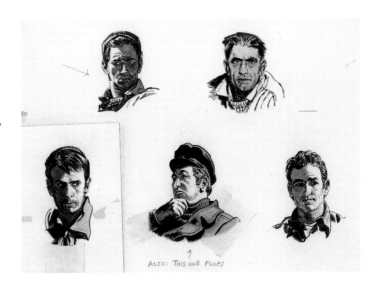

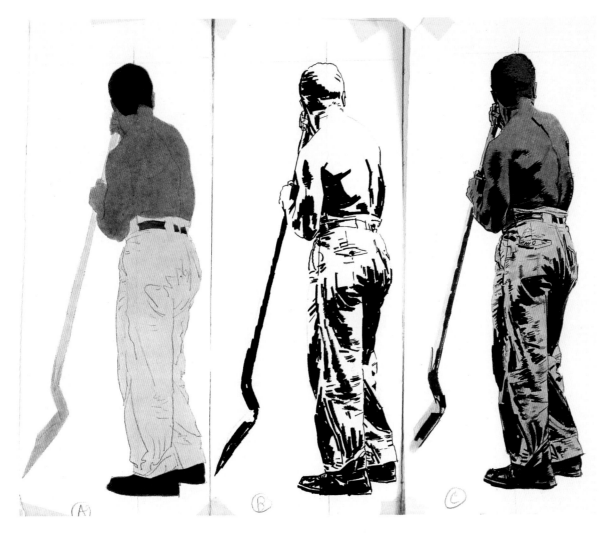

Robert Fawcett
Studies,
*Man with Shovel—
Rear View* (left) and
Five Men's Heads (above)
Pencil and ink wash
on paper
Ink and gouache
on board

"Remember," Austin Briggs wrote, "in order to describe an object you must have light, and light cannot be expressed without shadow." Nature has at its disposal an infinite and subtle range of values, but Briggs pointed out that the artist must make selective statements of light, dark, value, and pattern to create an effective work of art. "Once the basic areas of light and dark are expressed, we must decide from the nature of our subject which of the middle values" to employ.

Briggs uses both line and tone to create form in the drawings below and right. He varies his quality of line, from the light, breezy strokes of the woman's towel blowing in the wind, to the strong, dark line that describes the form and stance of the beachgoer in the foreground with her back to us. Spatial clarity is established simply—darker lines and tones delineate the figures closest to the viewer, while softer shades push others back in space.

In his sketches of a figure in motion, Briggs again employs lines of varying widths and shades to describe form. In the image on the

bottom right, he emphasizes the sweep of the woman's gesture by darkening the strokes of her hair, the curve of her back, and her right leg thrusting forward.

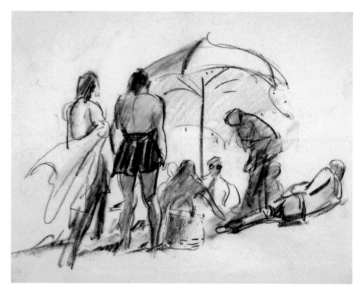

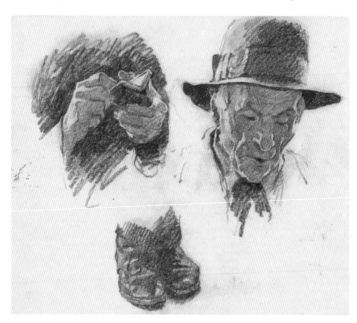

Norman Rockwell
Portrait of an Old Man, European travel sketchbook;
c. 1932
Pencil on paper

In these studies, the artist used light, dark, and middle tones to capture fragments of his subject. Light seems to be shining most strongly from the left-hand side and slightly above his subject, casting the right of the man's head, hand, and shoes into deeper shadow. Rockwell uses the broad side of his pencil to create tonal strokes and the point for crisp detail, as in the man's expressive face and his worn shoes.

Austin Briggs
Gestural studies
Ink on paper

CONSIDERING THE COMMON OBJECT

Draftsmanship was an important skill for the illustrators of the Famous Artists School, an ability they developed through the act of observational drawing. John Atherton often focused on the beauty of the common object, creating works that ranged from the highly realistic to the decorative. He noted that the illustration, at right, for United Airlines "has nothing in it that would seem to offer difficulty to the draftsman, but the very simplification of the forms themselves is what a good groundwork in drawing helps to accomplish." Sound drawing was essential to all of them, he said. "In each case I recorded what I saw and wished to use but I did more than that. I refined the forms which I did use and eliminated what I saw because some of the things were not essential." The ability to "observe intelligently and refine or exaggerate" was key to Atherton's success and a distinguishing factor in his unique brand.

John Atherton
Poster for United Airlines,
New Orleans

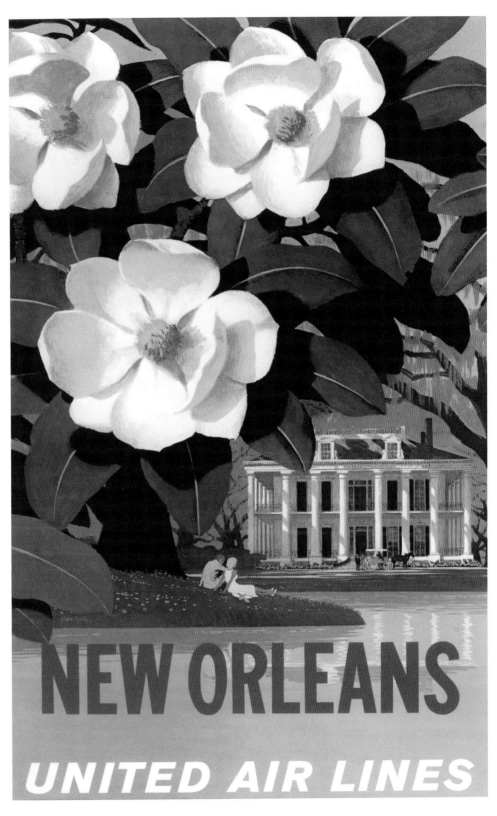

Atherton designed his New Orleans-inspired image, and others in a series, with prominent foreground elements framing a bucolic landscape. His beautifully conceived poster was derived from a series of streamlined drawings that introduced picture elements one at a time, from the magnolia blossoms to the graceful historic home.

(All images on this page)
John Atherton
Studies for
United Airlines poster,
New Orleans
Pencil on paper

Decorative structural elements at one point framed his image, but Atherton eliminated them from his composition, punctuating it instead with a couple on the lawn in the middle ground. Note the artist's use of directional arrows that point to the home in the distance and a numbering system that indicates areas of color and tone. Other drawings explored the possibility of featuring a New Orleans riverboat in the background rather than a historic structure.

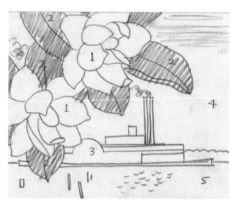

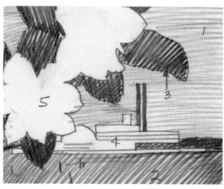

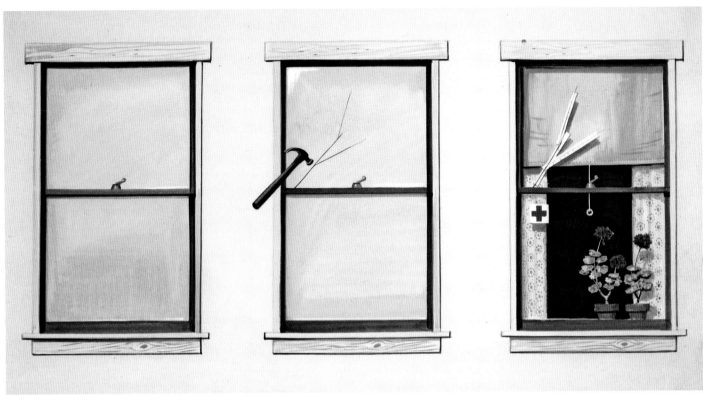

Stevan Dohanos
Variations on a Window
Gouache and pencil on board

NOW YOU TRY IT!

PROGRESSIVE DRAWINGS OF A SINGLE OBJECT

In his progressive study of a simple window structure (above), Stevan Dohanos's carefully observed series begins to take on narrative content. Dohanos offers three different views: the window with the shade pulled down, then with a pane cracked by a hammer, ending with the window taped and the shade raised to reveal colorful red geraniums on the windowsill.

- Do a progressive drawing that starts with a single object, like Dohanos's window or something of your choice—be it a glass, flowerpot, or car. Use your imagination but begin your series with observational drawing.
- In the first drawing, sketch your object simply, on its own.
- In the second drawing, add details that, in Dohanos's words, depict "the occurrence of an incident" that changes the object in some way.
- In the third drawing, introduce narrative content by embellishing the image further or by creating a setting that implies meaning. Add color to highlight important elements.

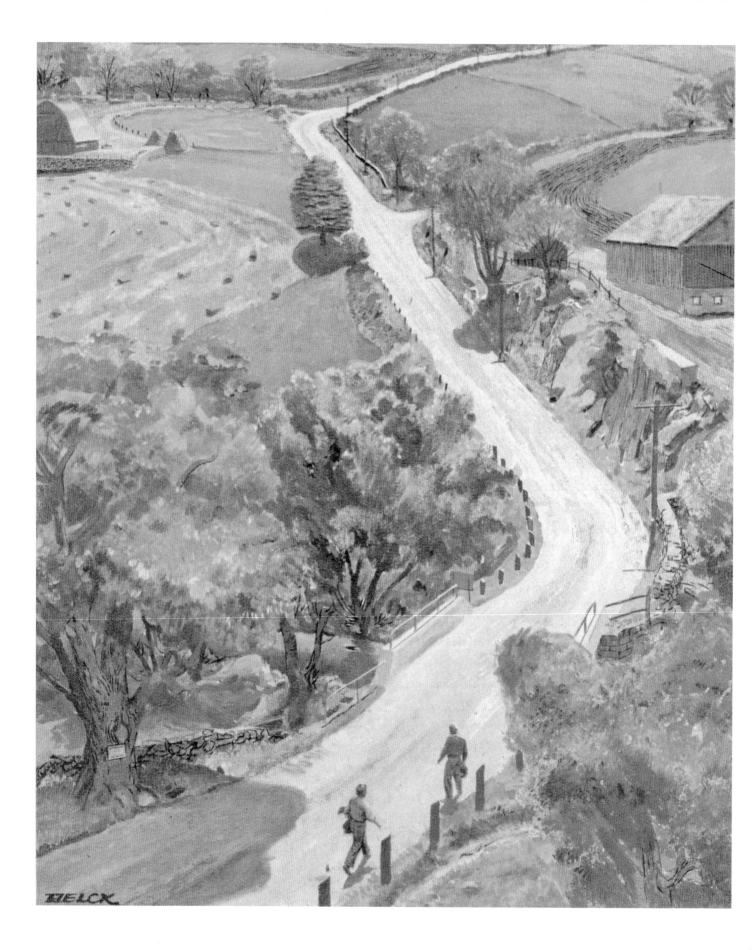

4 COMPOSING FOR BEST EFFECT

The root of a strong composition lies in relationships, through the purposeful arrangement of shapes, colors, patterns, tones, and forms. Compositional advice from the Famous Artists offers important tips on attracting and leading the viewer's eye, establishing a center of interest and point of view, and creating a strong sense of mood and drama in your art.

The painting shown opposite, by Peter Helck, embodies this approach and is a perfect introduction to the role of rhythm and movement in composition. The dominant element in this picture, the winding road traveling from foreground to background, lends a sense of movement to an otherwise still scene. Our eye follows it involuntarily, noting the small figures in the foreground and tracing with interest the passage of the road as it narrows and winds away into the hills. All the other picture elements must, by necessity, be subordinate to this sweeping graphic element.

Peter Helck
Advertising illustration
for ALCOA, 1951

MAKING COMPOSITIONAL CHOICES

To begin with, let's define composition in artistic terms: Composition means the orderly arrangement and distribution of forms, shapes, colors, and space. It is the use of artistic judgment in assembling the various elements of a picture to produce an effective whole. In other words, composition is the basic underpinning of an artist's work. Not surprisingly, each of the Famous Artists School founders had his own interpretation of what that basic tenet meant to him.

For Al Parker, composition was simply a pleasing arrangement of shapes. His advice was to start with one shape and fit others around it, and he reminded us that negative space can and should be an attractive shape. The weight and placement of shapes add to the mood and attract the viewer. Any details added later are only as good as the basic structure allows them to be.

Parker valued innovation above all, and as a result, he experimented with a wide variety of styles. Leaping beyond the constraints of traditional narrative picture making, he established a vibrant visual vocabulary for the new suburban life so desired in the aftermath of the Depression and World War II. More graphic and less detailed than the paintings of luminary Norman Rockwell, who was a contemporary and an inspiration to the artist, Parker's stylish compositions were sought after by editors and art directors for their contemporary look and feel. "Art involves a constant metamorphosis . . . due both to the nature of the creative act and to the ineluctable march of time," Parker said.

As seen below and opposite, Parker created striking illustrations for *Kinfolk*, Pulitzer Prize–winning author Pearl S. Buck's novel, which was serialized in three parts on the pages of *Ladies' Home Journal*.

(All images on this spread)
Alfred Charles Parker
Studies and illustrations for
Kinfolk by Pearl S. Buck
Ladies' Home Journal, November 1948
Pencil, ink, and gouache on paper

In this story illustration, Parker has made the most of interesting shapes that invigorate straight lines of text on the left-hand page: the prostrate girl, the spiky plant, the patterned rug. The cane is both an element of curiosity and an important diagonal that leads us directly to this story's protagonist. All contribute to an eye-catching and evocative composition. In this case, Parker's final visual solution varies little from his compositional study for the work.

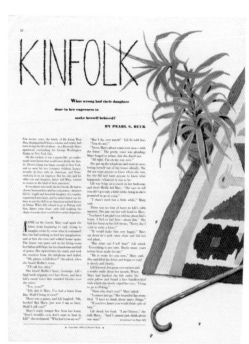

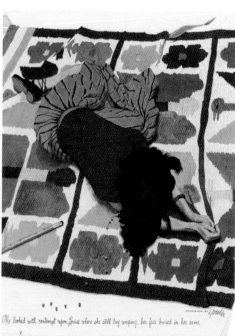

In *Kinfolk*, the children of a Chinese scholar living in New York decide to visit their ancestral village for the first time. The subject inspired Parker to emulate the graceful aesthetic of traditional Chinese brush painting in his art. Fashion designer Mary Suzuki was the model for this work, which also features a praying mantis on the edge of her bathing tub—a "stopper" intended to capture the reader's attention.

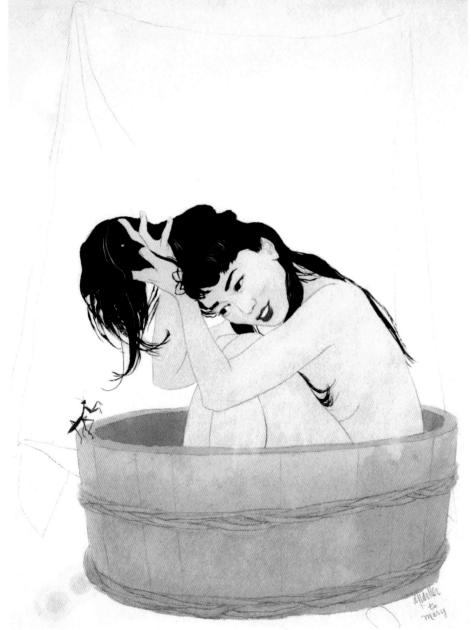

For Austin Briggs, the approach was simple: The first step was to establish borders. All the elements of a composition—shapes, lines, forms, and so on—have no meaning except as seen in relation to the borders or edges of the artist's paper or canvas. "There are two visual worlds," Briggs said, "the world of unlimited space which surrounds us and the limited world contained in four sides of our picture plane. From the unlimited forms in the world around us we select those we wish to put into our pictures." A picture presents "an entirely new frame of reference—its own four borders." Briggs explained that "the borders themselves become abstractions for the four directions, up, down, right, left." As illustrated in his simple drawings of a man running, the spatial orientation and movement of objects are established by their relationship to the borders of the page. The cropping of picture elements implies an extension of space beyond the image.

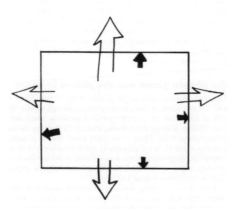
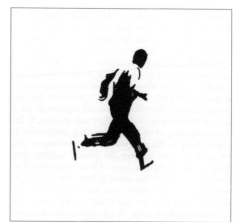
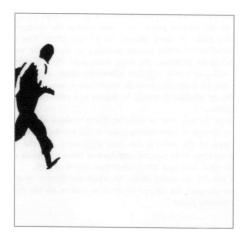
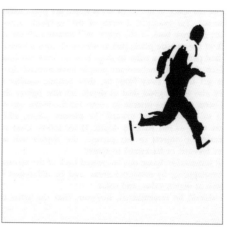

(*All images on this spread*)
Austin Briggs
Sketches illustrating various
compositional possibilities.
Ink on paper

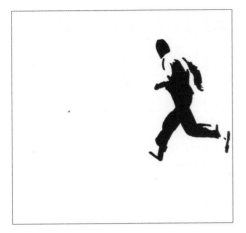

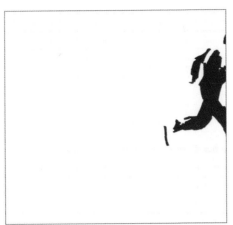

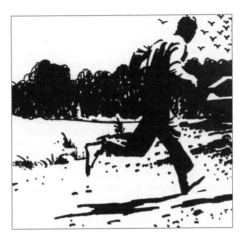

NOW YOU TRY IT!

EXPERIMENT WITH BORDERS

Take Austin Briggs's approach to experimenting with the borders of your picture plane by drawing a simple silhouette of a figure in any active pose, whether walking, running, pointing, or working. Use a photocopier to make duplicates of your image and cut them out. Then, place them—whole or cropped—in varied proximity to the top, bottom, and side edges of your paper. Which seems to work best? Once you've decided, paste your image down and develop a composition around it, as Briggs did with his running man.

Austin Briggs also gave us an inside view of the choices he made in creating an illustration for a story about the evacuation from Dunkirk during World War II. His challenge was to create a character and setting that would portray both a universal symbol of all brave soldiers and an intimate glimpse of one particular man.

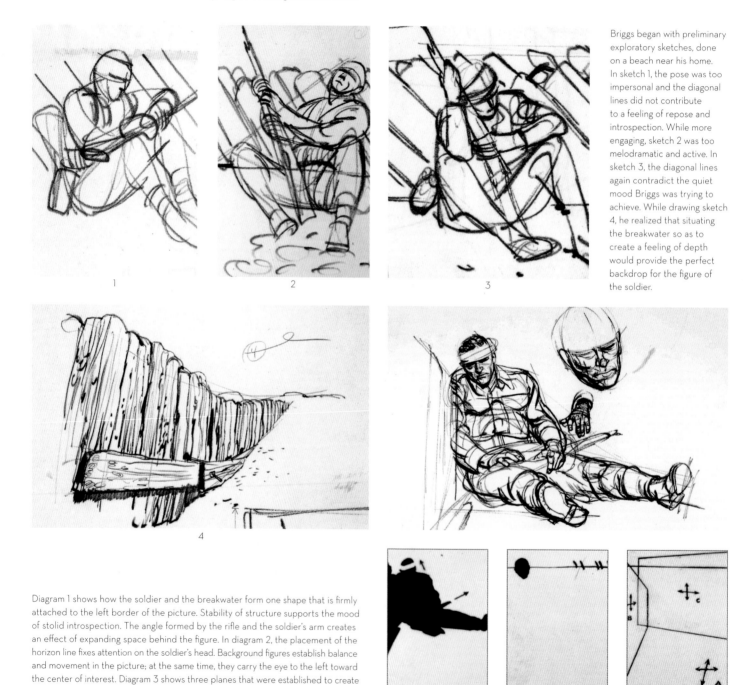

Briggs began with preliminary exploratory sketches, done on a beach near his home. In sketch 1, the pose was too impersonal and the diagonal lines did not contribute to a feeling of repose and introspection. While more engaging, sketch 2 was too melodramatic and active. In sketch 3, the diagonal lines again contradict the quiet mood Briggs was trying to achieve. While drawing sketch 4, he realized that situating the breakwater so as to create a feeling of depth would provide the perfect backdrop for the figure of the soldier.

Diagram 1 shows how the soldier and the breakwater form one shape that is firmly attached to the left border of the picture. Stability of structure supports the mood of stolid introspection. The angle formed by the rifle and the soldier's arm creates an effect of expanding space behind the figure. In diagram 2, the placement of the horizon line fixes attention on the soldier's head. Background figures establish balance and movement in the picture; at the same time, they carry the eye to the left toward the center of interest. Diagram 3 shows three planes that were established to create a sense of depth in the picture and mark out the "playing" space.

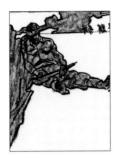 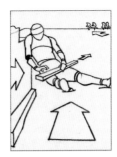 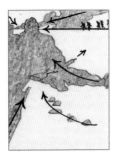

In these diagrams, we can see how each element in the composition is placed with definite intent to lead the eye and evoke a certain mood. With each decision and compositional choice, Briggs enhances the mood he set out to create.

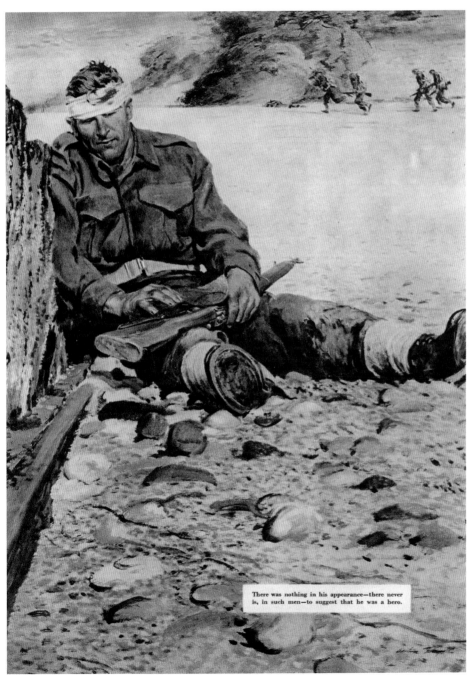

There was nothing in his appearance—there never is, in such men—to suggest that he was a hero.

(*All images on this spread*)
Austin Briggs
Sketches, diagrams, and final illustration for *One More for the Skylark* by J. B. Morton
The Saturday Evening Post, February 1, 1947

Now that we have defined composition, we must face the artist's universal problem: how to select the right materials and then change and rearrange them to deliver a clear, intelligible message. But there is more to consider when making compositional choices.

Harold von Schmidt tells us that "composition's job is to direct the eye and create a response in the viewer." In other words, the elements in the picture must be "composed" to create a certain mood.

So, here's the question to answer: What do you want the viewer to feel when looking at your picture? Von Schmidt has some suggestions. For a love scene, for instance, he recommends using picture elements that suggest a feeling of envelopment, of drawing together, of quiet. A picture of lovers should weave them together with line, tone, and color. In *Forgiven*, which accompanied a story in *Cosmopolitan* magazine, long diagonal lines unite the couple within the long sweep of the room. The man's face is purposely hidden to engage viewers with the woman's complex expression, and the two figures are linked as one—organic shapes framed by the geometric edges of the bench, table, and rug. "This is a sort of 'mother and child' concept," von Schmidt said. "Here was a case of 'her holding him' instead of 'him holding her' which you see so often, and the situation was too good to pass up."

In contrast, scenes of adventure should contain contrasting tones and strong diagonal lines that are not harmonious to the eye. Use angles, sharp corners, and opposing movements, as in von Schmidt's thriller, *Wing Walkers*, which features the cropped diagonals of the plane's body and wings. The human brain longs for balance and symmetry—when those are removed, we have a feeling of danger or unease.

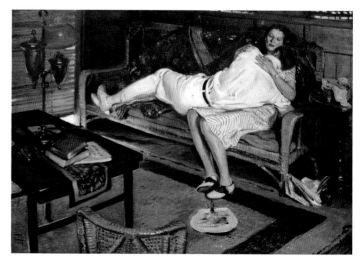

(*Both images on this page*)
Harold von Schmidt
(*Above*) *Forgiven*, illustration for *Cosmopolitan*, 1926
Oil on canvas

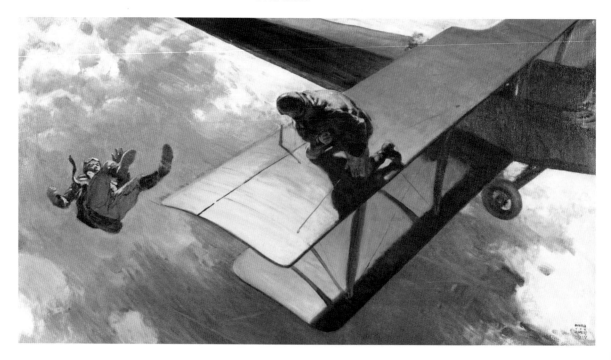

(*Right*)
Wing Walkers, 1929
Story illustration for
Lovers Leap by
Laurence Stallings
Liberty magazine,
April 6, 1929
Oil on canvas

ESTABLISHING A CENTER OF INTEREST

Knowing how to create a strong center of interest, or focal point, was essential for the Famous Artists, who considered it a skill that every artist should have. The center of interest is the area of an artwork that strongly attracts a viewer's attention; understanding how your audience will view your work will help you communicate more effectively.

There are many devices that can be used to ensure that aspects of your pictures become centers of attention. As Rockwell explains, some approaches are very straightforward. "One of the best ways to make an observer look at the point in a picture you wish him to see is to show the characters in your picture also looking at that point," he said. "The reader will also naturally look there, and that point . . . it becomes the center of interest."

Norman Rockwell
Roadblock (Bulldog Blocking Truck), 1949
Study for cover illustration for
The Saturday Evening Post, July 9, 1949
Oil on board

Using the alley adjacent to a Los Angeles boarding house as the setting, Rockwell presents a whimsical predicament. The artist posed as the violin teacher at the top right of the painting, and his friend, artist Joseph Mugnaini, posed as the window washer in the opposite building. They, and every other character in *Roadblock*, are looking or pointing directly at the painting's center of attention—the small bulldog who is causing all the trouble.

In the illustration below of the battle for the Alamo by Robert Fawcett, there is no doubt as to the center of interest: The wounded Texan is the dominant figure in the scene. His relaxed backward-falling figure symbolizes the failure of the defense. From there, the eye is free to roam over the rest of the picture, taking in the supportive elements. However, none of these elements is rendered in great detail. Fawcett said, "I have tried to suggest rather than portray . . . A hand gripping a wrist on the left, a dead Mexican's head with hat awry, a foot hanging on the rope—all these are small details whose eloquence suggests much more than is actually said."

Austin Briggs points out that it is possible to design an image with elements that convey the desired mood and have a good rhythmical relationship. "If the picture is to be effective," he said, "the eye must be drawn immediately to the important actor in the scene. There must never be any question as to what is important, and what the artist wishes to stress."

Robert Fawcett
The Fall of the Alamo,
1948
Ink (study) and
watercolor (final)
on paper

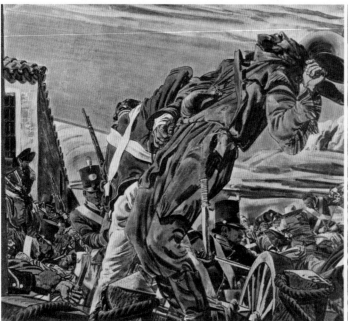
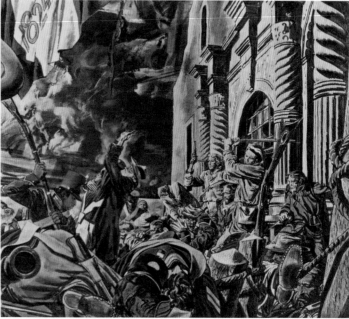

68

Briggs went on to detail the ways in which a center of interest can be created. The strongest contrasts of light and shade should be used there, along with the most detailed treatment of textures, the most interesting contrasts of color, and the sharpest of edges. All these elements will attract the eye to this important point. In the example on this page, the man bending down in the foreground is an "eye-catcher," while the real center of interest in terms of the story being illustrated is the girl on the sofa. Thus, the viewer's eye is caught and then immediately directed to the girl and her imminent interaction with the men in the doorway, as shown in Briggs's detailed diagram.

(Clockwise from top left)
1. Light door to separate important action from stooping figure
2. Picture on wall to relieve space
3. Coffee table for color and a comment on girl's pose
4. Ashtrays leading eye toward girl
5. Bottle aiming back into room
6. Rug pattern receding in depth
7. Eye path
8. Head explained more than in photo

Austin Briggs
Mary Pushed Her Fists into the Pillow and Pushed Herself Up, 1967
Ink on paper

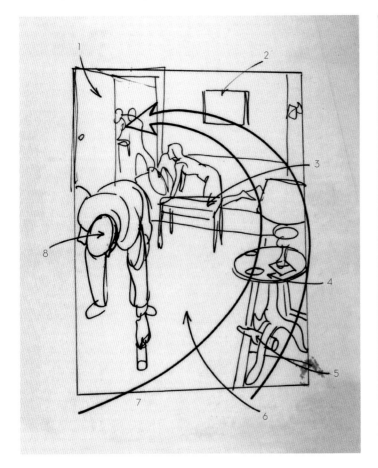

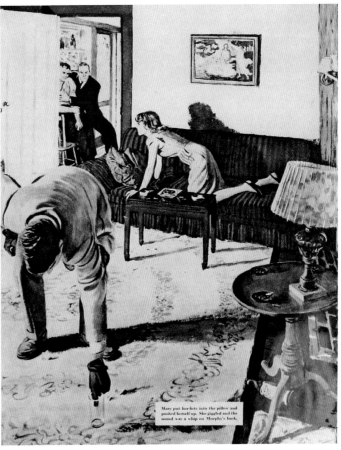

Taking a different approach to center of interest, *It Was the Nightingale* (right) showcases Al Parker's interest in abstract design. Two figures are featured in the work, but they do not dominate the composition, suspended as they are in a sophisticated network of shapes and colors. Parker has chosen to deny the spatial conventions of foreground and background in favor of a figure/field relationship—an innovation of modern design theory. Books, pillows, figures, and bric-a-brac, including the crucial white spaces between them, create a flat, pleasing visual structure. The emphasis on abstract pattern arrangement is usually associated with nonobjective works of art. Parker blends abstraction with narrative. Comedic touches are inspired by the story's theme, like the ceramic pheasants that appear to grow from his characters' heads.

John Atherton called composition "the framework that holds a picture together." For him, every picture required a certain architecture, pieced together with disparate elements: strong lines and forms, repetition, a path for the eye to travel freely. Atherton's recommendations for successful composition included concentrating the strongest lights and darks at the center of interest, keeping objects on the same plane, and keeping the light source consistent. In this example, Atherton shows how small changes in the placement of objects can create a more pleasing and compelling composition.

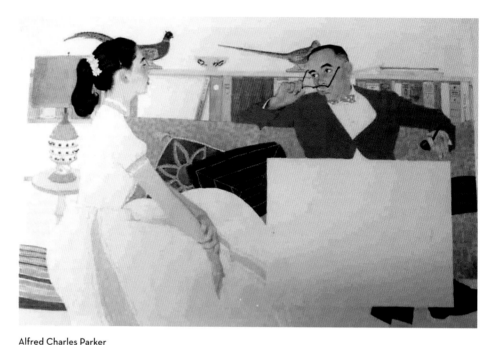

Alfred Charles Parker
Illustration for *It Was the Nightingale* by Ford Madox Ford, *Ladies' Home Journal*, c. 1961
Gouache on paper

John Atherton
Study and cover, corn harvest illustration for *Holiday*, August 1948

Atherton, who experimented with trompe l'oeil (trick the eye) techniques, carefully considered the placement and direction of the ear of corn in this *Holiday* cover. He also layered a secondary image—a hog eating corn—on top of his broad, flat depiction of an Iowa landscape. This unexpected visual element attracts the viewer's eye and interest.

LIGHT, SHADOW, TONE, AND VALUE

Ben Stahl discussed the importance of light and shade in terms of patterns, or masses, and their role in creating a sense of unity. He said, "A picture designed with a strong pattern of light and shade has much more strength and is much easier to grasp than a picture that does not have this quality." In addition, "There should be two dominant patterns in two contrasting values, one light and one dark, to hold and control the eye as it passes over the surface of the picture. The dark pattern may contain various lights, and the white pattern can be broken up with grays. But the basic patterns of light and dark should remain clear and unmistakable."

Compare this analysis of light and dark masses with the rough sketch it diagrams. There is a clear pattern of light, dark, and middle ground tones, all of which are planned to lead the eye to the center of interest, the woman facing us with tilted head. Although the sketch itself has many more details added, its clear pattern of lights and darks fulfills the artist's intent to focus the viewer's eye where he wishes it to go. Note Stahl's indication of a light source at the upper-left corner of his rough drawing.

(*Both images on this page*)
Ben Stahl
Pencil on paper

In this series of sketches by Al Dorne, we have the opportunity to watch the artist at work as he plays with different ways to approach the subject of a man at a desk who is apparently stymied or frustrated by the task in front of him. The dark/light pattern is clear in many of his sketches: This will be a dark subject against a light background. In the final version, we see how the heavily darkened foreground and the sequence of desk objects lead the eye to the center of interest —the man's face. His head in silhouette against the light background establishes a focal point and enhances our understanding of the man's frustration.

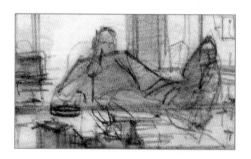
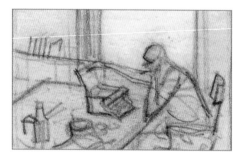

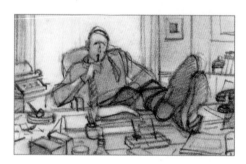

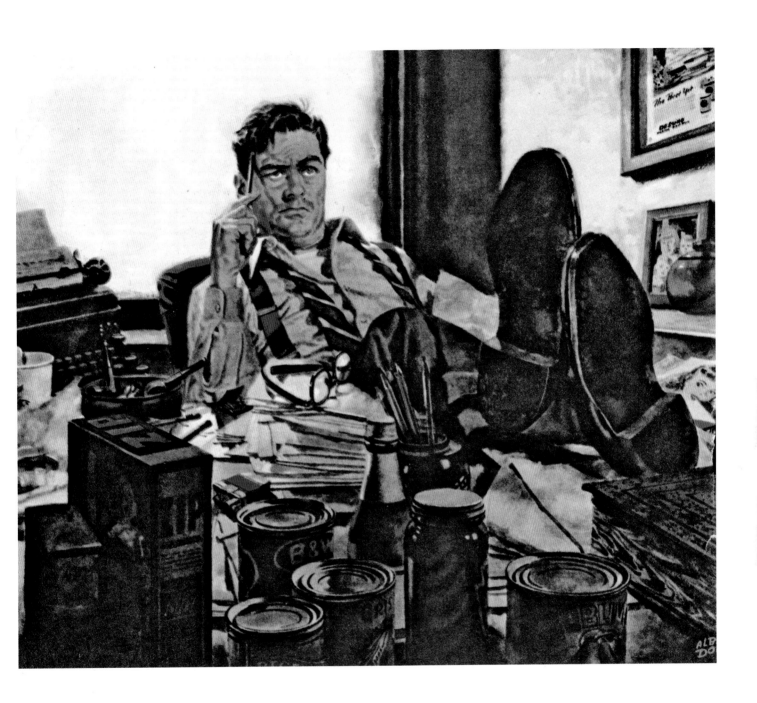

Harold von Schmidt took an approach similar to Dorne's. As shown on the right, von Schmidt said there were three basic structures for all pictures: 1 a light pattern on a dark ground; 2 a dark pattern on a light ground; and 3 and 4 a dark and light pattern on a half-tone ground. This third structure has two further divisions: when either 5 light or 6 dark predominates in the pattern.

(All images on this page)
Harold von Schmidt
Tonal Pattern Studies, c. 1948
Gouache on paper

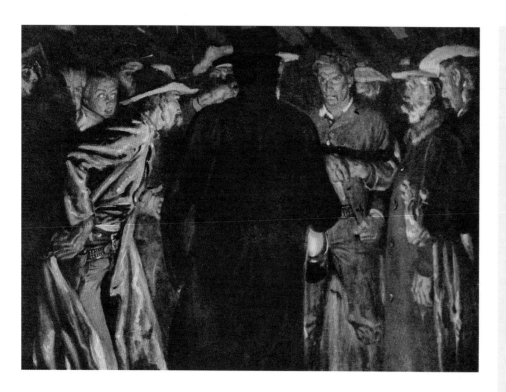

Story illustration for *Ruler of the Range*
by Peter Dawson, *The Saturday Evening Post*, 1951
In this dramatic story illustration, the center of attention is cast in deep shadow, surrounded by the light-bathed faces of the people he confronts. Bright spots punctuate the composition, which is generally dark in tone to create an air of mystery and suspense.

THE ROLE OF RHYTHM AND MOVEMENT

Peter Helck defined composition as the art of dividing a flat surface into areas of line, pattern, and tone, which combine to produce a distinct impression of unity. "Within this unity," he said, "will appear an element, shape, or form of supreme importance which attracts the sight and sensibilities through the subordination of all other elements."

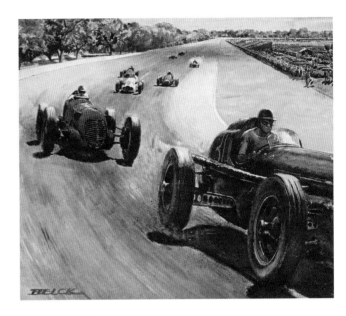

(Both images on this page)
Peter Helck
(Above) *Murder Car*, 1951
Illustration for *Murder Car* by William Campbell Gault

(Left) Advertising illustration for Chevrolet trucks, 1943

These two Helck illustrations use a rhythmic pattern to strongly evoke movement—the trucks kicking up water on the wet pavement, the eternal ebb and flow of commercial traffic through the countryside, the repetition of vehicles in receding scale, the looming race car as it rushes into the foreground followed closely by pursuers. We can almost hear the tires on the asphalt, the whine of the engines.

Austin Briggs used visual rhythm to awake emotional responses in his viewers, believing that "the stronger and more direct the rhythmic appeal of the picture, the broader and more universal its emotional appeal will be." In the drawing at right, Briggs analyzed the rhythmic gestures of a female figure and her interaction with a fallen man. His two tonal studies inspired by the subject establish a close rhythmic connection between the two figures, in which their arms seem to extend from one another as one graceful line.

For Ben Stahl, rhythm was a basic quality of every successful painting. He said, "A single line, moving through a picture, will be more pleasing if it flows along in a rhythmic pattern. Rhythm in a picture attracts and pleases the eye just as the recurrent pulses in music please the ear."

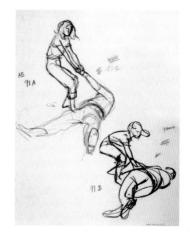

Austin Briggs
Studies for *My Love Will Come* by Dorothy Cottrell, *The Saturday Evening Post*, February 1948
Ink on paper
Gouache on board

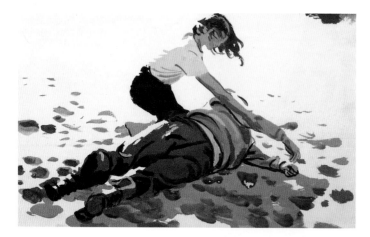

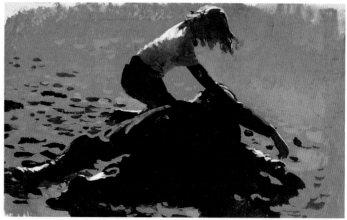

Ben Stahl
Jack of Swords, 1949
Story illustration for *Jack of Swords* by Gerald Kersh, *The Saturday Evening Post*, October 8, 1949
Oil on board

In this story illustration, Stahl links the figures in his horizontal composition with rhythmic lines conveyed through gesture, areas of light and shadow, and picture elements, like the knife and tilted candles.

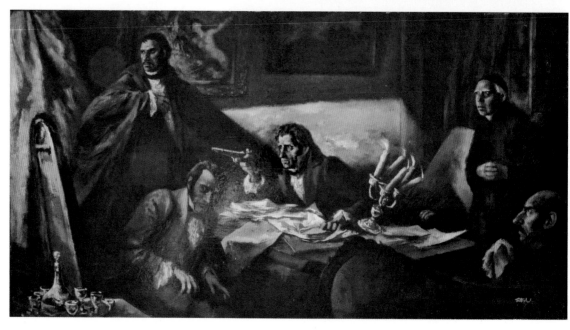

Of necessity, a picture of a bar fight must be filled with animation and movement. Fred Ludekens had an assignment to illustrate a scene from a rough story of rough men, a construction story about pile drivers, heavy equipment, and brass knuckles. The situation he chose to illustrate was described in the manuscript as follows: "He straightened that one with a full hard right to the jaw. The man went down, sliding on his back into the tables." As shown below, Ludekens began by sketching the whole scene.

Ludekens said, "My plan in this picture was to carry the action across two pages by force of composition and action. I used chairs, tables, figures, bottles, arms, back, posture of figures, everything, to force the feeling of thrust." This first sketch looked pretty good to him, but he thought the movement in the picture could be improved if he changed the striking figure. He experimented with different positions, angles, and orientations of that central figure, as well as the figure of the falling man.

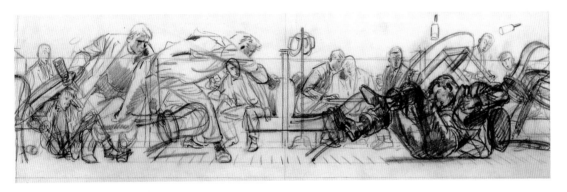

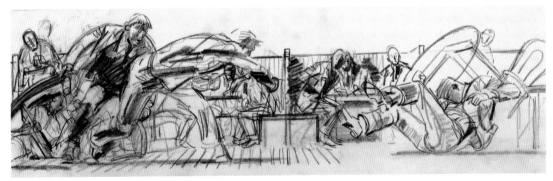

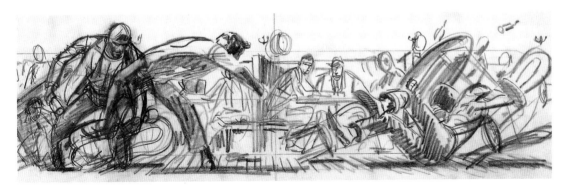

Fred Ludekens
Studies for *Up Stepped McGonigle* by John and Ward Hawkins, *The Saturday Evening Post*, January 13, 1951
Pencil on paper

In the end, Ludekens decided that his first sketch was the best, though he did modify the falling man slightly based on his experimental drawings. And, he said, he learned an important lesson: "When you place figures together, each becomes related in composition and design to the other." He realized he was concentrating too much on one individual part of a picture without drawing it in combination with the other parts. "To me the drawing of the identical forms change in each picture because in each picture different areas of space and of tone are prevalent." In other words, creating a sense of movement and rhythm in a picture can only be done effectively by considering all the elements in concert, rather than as separate entities.

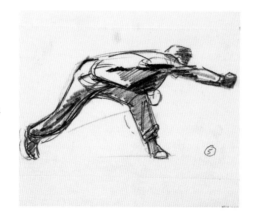
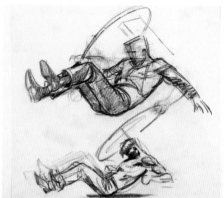
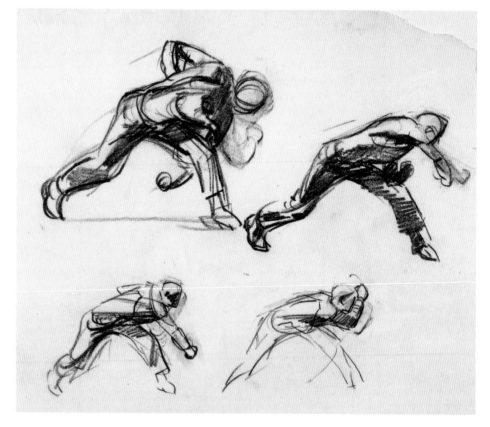
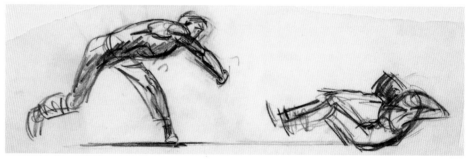

Studies for *Up Stepped McGonigle* by John and Ward Hawkins, *The Saturday Evening Post,* January 13, 1951
Pencil on paper

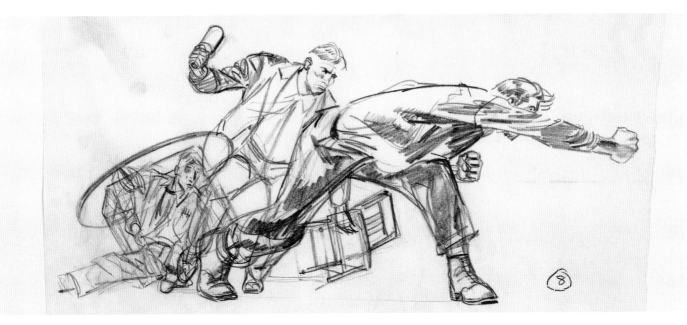

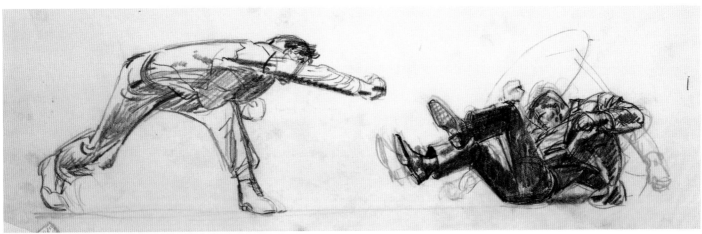

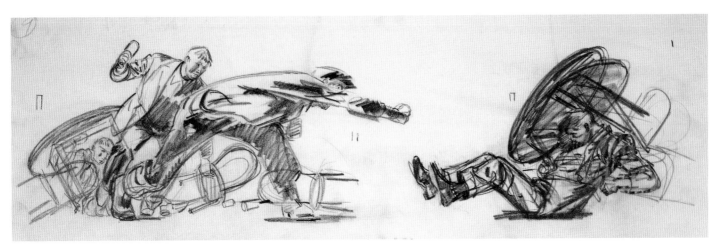

Ladies'
Home

JOURNAL

The Magazine
Women
Believe In

February, 1949
25 cents

5 THE WELL-DESIGNED IMAGE

As the Famous Artists frequently emphasized, a well-designed page is visually coherent, technically sound, and able to convey emotion and information in a dynamic, effective way. In this chapter, position, balance, color, contrast, size and scale, attitude, and the use of symbolic elements are explored from the viewpoints of these accomplished illustrators, who were all gifted designers as well.

The Famous Artists were, by and large, commercial artists—that is, they produced work on assignment for magazine covers, story illustrations, advertisements, posters, books, and more. Although they occasionally drew and painted for their own pleasure, they were dedicated visual communicators who sought to connect with a broad, popular audience through the printed page. Thus, they each established effective approaches to visual design that could be called upon when constructing artworks for publication.

When creating his famous mother and daughter cover illustrations for *Ladies' Home Journal*, Al Parker eliminated distracting backgrounds in favor of clean poster designs that emphasized strong, simple forms and recognizable narratives. Here, he activates his composition by contrasting flatness with volume—linear figures are juxtaposed with areas of opaque color and naturalistic faces. Red hats connect each of his subjects, as does a lively pattern created by white gloves and a patch of snow atop the younger child's head. He also took time to design a decorative font that relates aesthetically to his layout and painting style. A true innovator, Parker wrote, "After I have chosen the situation I want to illustrate, I try to avoid any hackneyed or stereotyped approach or arrangement. I pretend I am seeing the figures and props for the first time and discard any preconceived ideas I may have of them."

Alfred Charles Parker
*Mother, Daughter,
and Son Sledding*, 1949
Cover illustration for
Ladies' Home Journal,
February 1949

FORM FOLLOWS FUNCTION

Even before the artists took up their pencils to sketch out ideas, constraints for particular assignments were already in place in terms of scale, layout, color, and many other details that were dependent upon a client's needs and expectations. They had to work within, and sometimes around, these concerns to produce art that would do the job, satisfying both the client and themselves. They worked directly with art directors for magazines and advertising agencies—in the age of print media, their imagery wielded a great deal of influence. At the top of their careers, the founding artists were in great demand and their particular styles and talents were well known. Nevertheless, they had to find creative ways to meet requirements that posed compositional and practical challenges.

For example, for an advertising assignment, Fred Ludekens made the sketches at right of a horse and rider watching a train wind through the landscape of the far West. The client was the railroad company; the painting was to be part of a two-page spread advertising the pleasures of a cross-country trip by train. The client did not want to show the locomotive or the observation car, but did want to depict the landscape that the train would be passing through. As indicated in Ludekens's sketch, the painting was to be part of a layout in which another image would overlap its lower right-hand corner, so the artist had to plan his composition to make this as unobtrusive as possible.

Other technical considerations in regard to magazine work exerted great influence on how artists prepared their work. Ludekens explained that he used a great deal of black in his paintings because after passing through the printing process, a picture that used realistic colors could often end up looking washed out, with all contrast lost. Given that the function of the illustration is to stop the reader and involve him in the action, the illustration must make a strong statement. Ludekens said, "The subtleties of tone quality and minute detail are only important to me if the statement and the impact are there first. I want no question in the reader's mind as to what I am trying to say. If the man is being shot in a western, let's be sure that he's being shot. Every symbol and every attitude I can think of will be used to give clarity to the statement." The artist's use of dark values in the work at far right is punctuated by spots of brightness to establish mood and bring the viewer's attention to important aspects of the composition, such as his figures' faces, hands, and expressions.

Designing images for magazine covers presented a different challenge. An image for a cover had to incorporate maximum display value while including the details necessary to not only attract but also hold the viewer's attention. In most cases, any one of a number of approaches might be successful; as seen opposite, the final decision was often a collaboration between artist and art director.

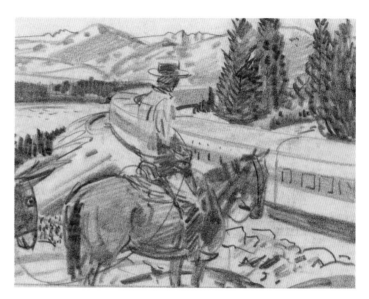

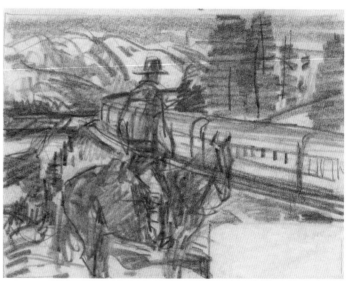

(*All images on this page*)
Fred Ludekens
(*Above*) Studies for railroad advertisement
Pencil on paper

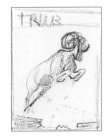
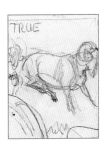

Fred Ludekens
Studies and cover
illustration for *True*,
March 1947
Pencil on paper

Sometimes, experimentation with a variety of compositional approaches is helpful in establishing a strong visual solution. Before settling on this striking portrayal of a sturdy mountain goat for the cover of *True*, above, Ludekens explored more action-packed options, featuring the animal in mid-leap or running toward the viewer. Ultimately, he decided to emphasize the regal qualities of his subject by placing the mountain goat on a high peak looking off into the distance. Note that the white snowy mountain allows Ludekens to emphasize its silhouette; the goat's form and the mountain's curve intersect just left of the cover's center.

Fred Ludekens spoke for his fellow artists when he discussed the concept of "page impact." He said, "The ultimate to me is a combination of both design and idea in the most simple, telling statement. . . . It is best when idea and design work together." Ludekens always kept in mind the importance of good page design while he worked on the most dramatic way to lure readers into a story. In this illustration, for example, there is plenty of action and lots going on, but the picture is pulled together around the central figures, and the page has unity, which directs the reader's eye and attention to the artist's predetermined focal point.

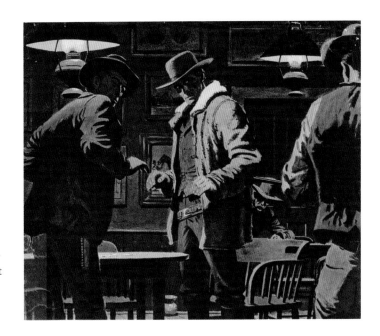

"You!" Fasken said to Lee, "Move away!", 1949
Illustration for *Vengeance Valley* by Luke Short
The Saturday Evening Post, December 10, 1949

"There was one kind of idea which I didn't have to struggle over—the timely idea," Rockwell said. "I'd just keep my ear to the wind and, when I heard of a craze or fad or anything which everyone was talking about, I'd do a cover of it." *Welcome to Elmville* was one such idea. Norman Rockwell said that at the time, rather than imposing new taxes on their citizens, towns were hiring police to set up speed traps and "fine their victims heavily." The model for this pose was not one of the many professional models engaged by Rockwell when he lived in New Rochelle, New York. Instead, he chose Dave Campion, the owner of a local news store, for this and other images that required a character who was tall and lean. Positioning him in a crouching position gives his body angles that create movement, and the diagonal nightstick and shadow add to this effect. Streaks of white paint in the foreground tell us a car has just gone speeding by.

NOW YOU TRY IT!

FORM FOLLOWS FUNCTION

Choose an image that you have developed, in whole or in part, and adapt it for one or all of these possible uses and formats:

- A smart phone or web page
- A double-page spread for a book or magazine
- A calendar illustration

What changes need to be made to accommodate these uses of your art? Write a caption or a line or two of text to accompany your image, and design it into your layout for best effect.

Norman Rockwell
Welcome to Elmville, 1929
Cover illustration for
The Saturday Evening Post,
April 20, 1929
Oil on canvas

THE ELOQUENCE OF SIMPLICITY

When Ben Stahl was a young artist, his mentors often told him to "keep it simple." He found that hard to do: He loved drawing every single leaf on a tree. However, he "began to see the eloquence of pictures that possessed this restraint and simplicity." It's not easy to paint that way—"to attain simplicity while maintaining the true essence of a scene is most difficult."

Ben Stahl
Story illustration for
Fugitive From Terror
by James R. Webb for
The Saturday Evening Post,
April 23, 1949
Oil on canvas

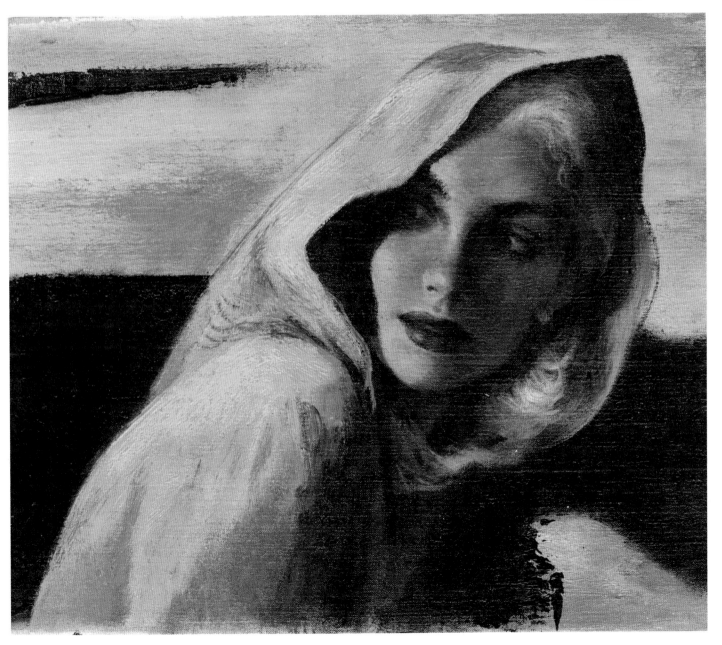

Austin Briggs, too, talked of simplicity. He cautioned the novice painter against including unnecessary detail, and counseled restraint in introducing extra shapes and forms, excessive colors, or too many different tones and values. The elements of the image must be designed to work together, to complement each other rather than battle for the viewer's attention. An artist is much more successful, he said, "when he chooses a limited number of well-assorted ideas, and presents these in a coherent, interesting, and forceful way."

John Atherton advised his students to "try to cultivate the ability to make a *picture* out of each subject," even when making simple studies. "When you jot something down on a sketch pad that you think is interesting, always think of your sketch as a picture as well as a study. Place it on your paper or other materials so that it forms a pleasing and effective composition. In studying the sketches of the great masters of the Renaissance, I am impressed constantly by how beautifully *composed* they are." He challenged artists to think of each drawing as a finished picture, "framed by the four sides of the paper or canvas."

Austin Briggs
In this drawing, Briggs eliminates unnecessary detail and leads our eye directly to the focal point—the boy who is more interested in eating the turkey than expressing thanks for it.

John Atherton
Studies for Duck Hunters, c.1953
Pencil on paper
In these composition sketches, John Atherton was searching out the grouping that would create visual interest and be both simple and direct in telling the story. Small changes indicate his thinking process: Separate one hunter from the group, or bring them closer together? Push figures back in space, or bring them forward? Raise or lower the horizon line? Small adjustments to the main elements of a picture can impact both meaning and design.

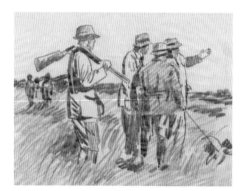

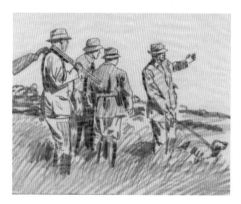

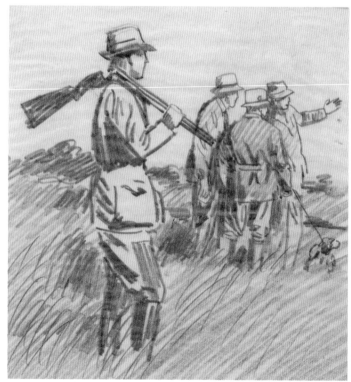

THE USE OF VISUAL SYMBOLS

The illustrators of the Famous Artists School worked largely for publication, and their art for magazine covers, stories, and advertisements was seen and enjoyed by a vast and varied audience. They knew they had just seconds to capture a reader's attention, tell a cohesive visual story, and engage their audience sufficiently, so as to inspire the purchase of a magazine. To accomplish this, artists found inventive ways to incorporate common, recognizable symbols that conveyed meaning and also had a strong graphic identity. Simple but striking symbols are employed in Atherton's July 4th illustration, in which a lovable Scottish terrier is delivered with a happy birthday tag in a box of patriotic colors in celebration of an all-American holiday.

John Atherton
Present, Scottie Dog in Gift Box, 1938
Cover illustration for *Woman's Home Companion,* July 1938
Gouache on board

To celebrate the February 12th birthday of President Abraham Lincoln, Norman Rockwell painted this cover illustration featuring an apron-clad store clerk immersed in study. Although Lincoln had worked as a clerk and became part owner of a store, it was not until two years later, after he had begun a political career as a representative in the Illinois General Assembly, that he began working toward a law degree. The point is well taken, however. This young man is buried in his books rather than the business at hand, and portraits of Lincoln, tacked to the wall, are there to provide inspiration. *The Law Student* is one of Rockwell's symbolic portrayals of the American dream, presenting the notion that with diligence, a person of meager means can aspire to any height. The books, barrel, apron, photographic clippings, and paperwork are symbolic elements that help Rockwell construct his narrative.

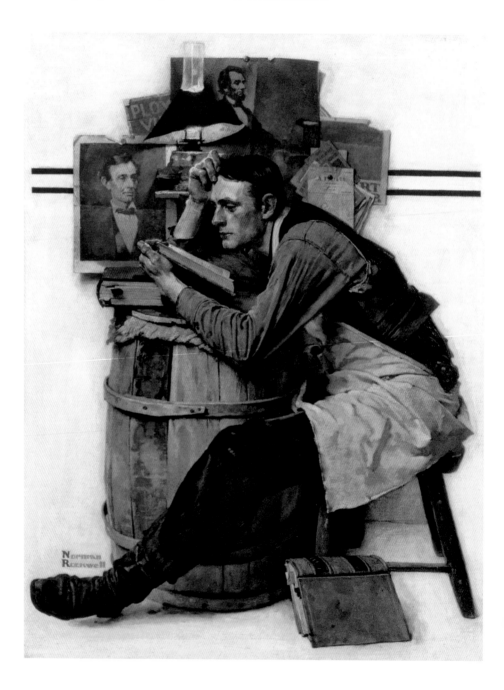

(*This page*)
Norman Rockwell
The Law Student, 1927
Cover illustration for
The Saturday Evening Post,
February 19, 1927
Oil on canvas

(*Opposite*)
Stevan Dohanos
Mailman, 1944
Cover illustration for
The Saturday Evening Post,
May 13, 1944

Stevan Dohanos's mailman seems determined to uphold the United States Postal Service motto: "Neither snow nor rain nor heat nor gloom of night stays these couriers from the swift completion of their appointed rounds." Seen from behind as he walks his route under the shelter of an enormous umbrella, the mailman portrays an everyman completing the work at hand no matter the challenges. As seen here, a symbolic figure viewed from the rear has long functioned as a stand-in for onlookers themselves. We march along with Dohanos's mailman, whose satchel is weighed down with the remainder of his deliveries. Note how the artist frames the figure with narrative and graphic clues. Set in a bucolic suburban neighborhood inspired by Westport, Connecticut—the town where both he and the Famous Artists School resided—the composition includes a bright red fire hydrant on the right balanced by a red-roofed home and blossoming magnolia tree on the left. "Do not feel that realism in a painting rules out abstract qualities and design. It simply is not true," Dohanos said. "No matter how much an artist copies a subject he is still 'designing' it in terms of size and color, and giving it unique character with the infinite number of things he leaves in or takes out."

NOW YOU TRY IT!

THE SYMBOLIC NARRATIVE

Create a symbolic artwork that represents you or someone you know. Choose one of the following approaches, or experiment with both.

Jump Off Stevan Dohanos's Pictorial Design

- Draw inspiration from Dohanos's compositional structure by drawing or painting a central figure with his/her back to the viewer. Is your subject on the job, like the artist's, or engaged in another activity or task, such as looking at a painting in a museum, running for a bus, or entering a room?
- After you've decided on your scenario, surround your figure with details that help establish a narrative. Balance your composition through the purposeful distribution of color, shape, and form in the medium of your choice.

Design a Symbolic Portrait

- Decide whom your symbolic portrait will represent, whether yourself or someone else.
- What visual elements represent your subject's interests, occupation, place of residence, cultural background, and aspirations? Your image need not feature a likeness of the person; instead, construct your piece with thoughtfully chosen elements in a well-designed arrangement.
- In Dohanos's design, there is a dominant form surrounded by supporting details. Use this as a guiding principle for your artwork.

REPETITION, VARIETY, AND NOVELTY

In designing an image, Austin Briggs pointed out, the artist has three possible ways to handle the various pictorial elements. One could take a shape and repeat it over and over again. A second possibility is to take an idea and change it subtly each time it appears, which gives both consistency and interest to the painting. The third is to introduce a completely new element into the composition, which strengthens the others by contrast and keeps the composition from becoming dull and predictable.

In this depiction of a coldhearted sniper, Briggs used the setting and props to reinforce the character of the man through a technical arrangement of structure and pattern. He decided that his figure must be still yet contain the suggestion of potential motion. Contrasting with the controlled tension of the man, the background suggests the "nervous instability of his emotions," wrote Briggs.

Briggs tried a number of different poses, from standing to sitting and squatting, noting that "when one stops to realize the many different viewpoints from which the action can be seen, the possible differences in pose and relationship of forms, the differences in lighting effects which might be achieved, it is obvious that the mere statement of a scene chosen more or less at random is not enough. A variation in any one of these factors could produce an entirely different effect." Briggs's final composition features a "coldblooded, quiet, and methodical" gunman looking toward an enemy beyond the edges of the picture plane. His motif features a triangle set off balance on its point. After trying many variations, Briggs realized how much drive he could get in the composition "by bending the man's leg and making it join to the rifle barrel to form a triangle."

(*All images on this spread*)
Austin Briggs
Studies and final illustration
The Sniper
Ink on paper (studies) and
gouache on board (final).

The triangle theme is repeated with variations in the background, and for novelty, curvilinear lines are formed by tree branches and by two figures who quietly emerge from behind. These components contrast effectively with the almost mechanical rendering of the shooter, creating an interesting and suspense-filled composition.

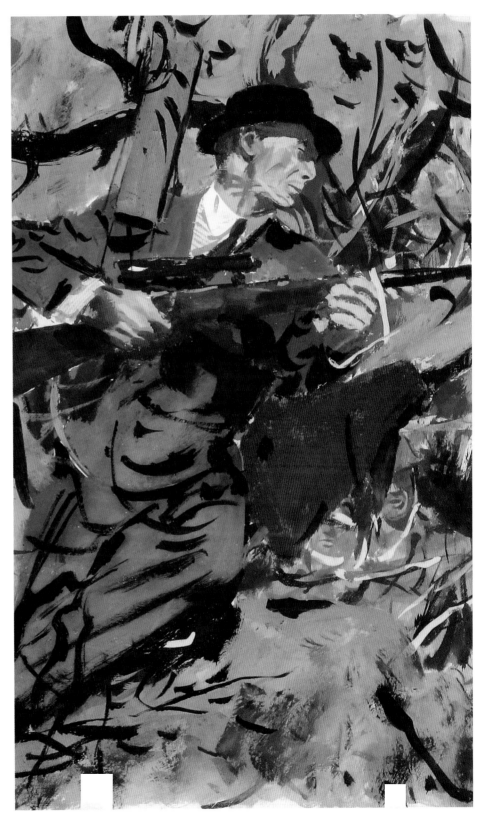

Fred Ludekens
Western scene
Ink and gouache on paper

In this striking study for a Western illustration, Ludekens used black ink on colored paper to delineate strong geometric shapes that create visual interest. The black-ened rectangles of the door and windows repeat and move the viewer's eye across the composition, while the rectangular roof offers variety. A pattern of bright whites moves across the picture plane, calling attention to the three hunched figures at its center, leaving little question of what the artist wishes you to see. "I am not trying to duplicate nature, I am trying to make a picture," Ludekens wrote. "I am very conscious of this pattern because I make it the structure of my picture."

Norman Rockwell
Going and Coming, 1947
Cover illustration for *The Saturday Evening Post*,
August 30, 1947
Oil on canvas

In Rockwell's *Going and Coming*, we see the before and the after of an imagined event—a family's summer outing by the lake. Clues abound for the reader's enjoyment in unraveling the story line. The use of a split canvas to juxtapose a time or place effectively invites comparison between the two scenes. This technique is employed by Rockwell in only two other covers, and is derivative of a comic strip's use of a series of frames to tell a story. In this case, parents, children, and even the dog are repeated top to bottom with variety, but the stalwart grandmother remains steady, connecting the top-right and bottom-left portions of the painting.

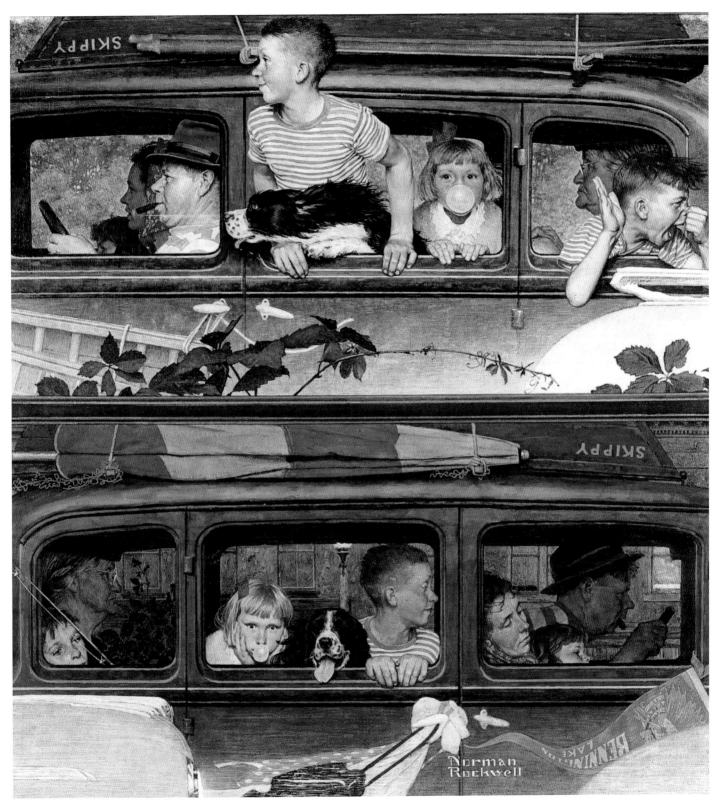

6 DRAWING THE FIGURE

The human form has been a central focus of artists through the centuries—compelling to observe, people and their actions carry meaning in any artwork. Portraying the figure in motion and in space, casting and working with models, and creating photographic reference for your art are themes explored in this chapter in lively detail. An intimate knowledge of the figure was essential for each of the Famous Artists, who relied upon their characters to convey narrative and emotive content.

In his graceful sketch of a leaning man (opposite), Briggs describes form by emphasizing the curvature of his back and showing the volume of his body in the horizontal wrinkles of his jacket. A loosely cast shadow on the back of his head, and on the left side of his arm and trousers, gives the sense that he is a three-dimensional being.

Austin Briggs
Study for *Crisis in the House*
by Ralph Knight,
The Saturday Evening Post,
March 12, 1949
Pencil on paper

CASTING AND POSING YOUR CHARACTERS

After composition, what determines the success or failure of an illustration is the action and expressions of the characters. And why not? The human figure is one of the most fascinating and rewarding subjects any artist can tackle. Few things interest us more than the men, women, and children we see around us. The liveliness and energy in the vast majority of artworks by the founding artists are directly related to their skill at making characters true and believable. We, as viewers, can almost hear whispers, shouts, laughter, and weeping because of the actions and expressions of the characters—no words are needed.

Artists cast their characters as carefully as any stage or movie director, for an illustration must capture a moment in time. So, very early on in the process of creating an illustration, artists take time to consider the individuals who will bring their work to life.

With an eye on the visual narrative, Norman Rockwell went to great lengths to populate his images with just the right models, or types. Unlike other artists who engaged professional posers, Rockwell hired his family, neighbors, friends, and fellow artists to act out the characters in his paintings to great effect. Following a series of thumbnail sketches in which his concept and composition were sealed, he scouted models, costumes, props, and locations, and captured the essence of character and expression in nuanced black-and-white photographs—sometimes up to 100 for a *Post* cover. "Directing models so you can get the right poses for your pictures is an art in itself, and is somewhat akin to the motion picture director's job," Rockwell wrote. "Before a model even attempts to pose for me, I tell him the story I want my picture to tell because I want him to understand what I am trying to do, what I am trying to convey. Then, I get into the pose myself and show him how I think it should be done." The camera captured countless necessary details, from the subtleties of facial expression and body language to the folds of a model's dress. This all but eliminated repeat modeling sessions and high professional fees, an advantage in a deadline-driven field. "Now anybody could pose for me," Rockwell said. Photography's spatial ambiguity, oblique angles, extreme perspectives, and cropped edges offered new ways of seeing, and choice photographic reference could be retained and filed away for future consultation.

Rockwell's *Post* covers generally derived from his imagination or were inspired by scenes that he had witnessed and remembered, but *Saying Grace* was one exception. In the fall of 1951, the artist received a letter from a woman in Pennsylvania who described something that she observed in a Philadelphia Automat restaurant. Seated at a table, she observed a young woman with a little boy of about five. They walked by her with food-laden trays, situating themselves at a table where two men were already seated, "shoving in their lunch." Despite this, the young woman and boy folded their hands, bowed their heads, and said grace.

As shown on the following spread, Rockwell used this description as a jumping-off point.

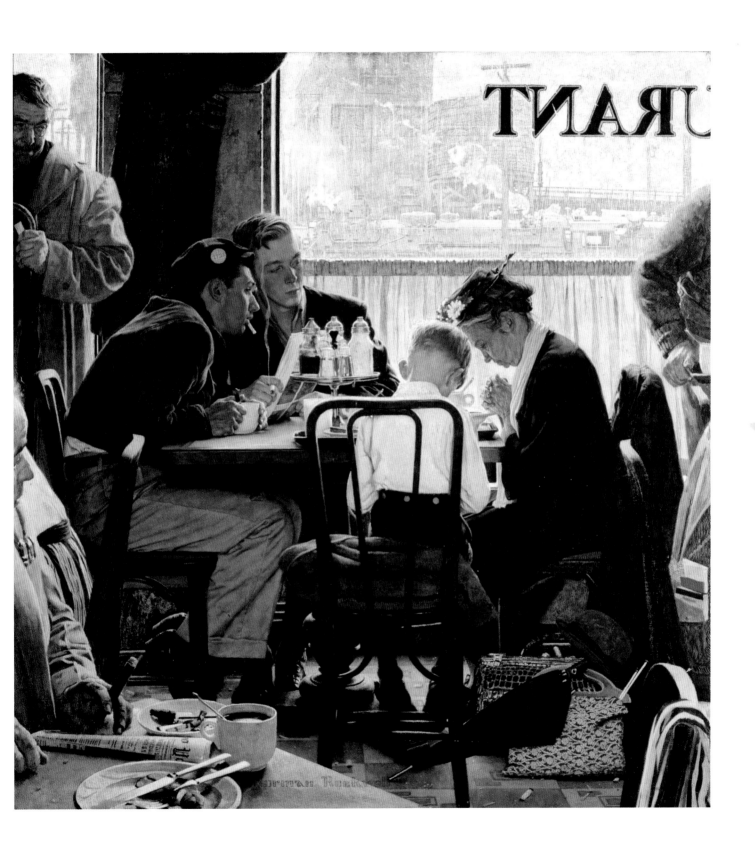

Rockwell hired a photographer to take photos from inside a Horn & Hardart Automat in New York City, ultimately deciding on a view of industrial buildings in Rensselaer, New York. Earlier versions of the scene through the window were busy with storefronts, cars, buses, and people. Rockwell likely found this to be too distracting; he substituted the natural gray tones of structures shrouded in smoke, which allowed them to blend away in the background. Hearing the facts of the actual incident and then seeing how Rockwell developed it is an interesting study. He adjusted the age of the woman and emphasized each diner's reaction to a moment of prayer in an unlikely setting. A stickler for detail, Rockwell ensured that what he did not have on hand could be borrowed, purchased, or rented. In this case, the chairs and tables were brought to his Arlington, Vermont, studio from a New York City Automat, and returned when the project was done.

(Near right)
Industrial setting in Upstate New York.

(Far right)
Modeling sessions in Rockwell's Stockbridge, Massachusetts, studio.

(Near right)
Platform constructed to situate models against the windows in his Stockbridge, Massachusetts, studio.

(Far right)
New York City scene from Inside Horn & Hardart Automat in Times Square.

(*All images on this spread*)
Gene Pelham
(1909-2004)
Photographs for
Saying Grace, 1951
Cover illustration for
The Saturday Evening Post,
November 24, 1951

(*Clockwise from above left*)
Jarvis Rockwell and friend
in Rockwell's Stockbridge,
Massachusetts, studio.

Norman Rockwell directing
wife Mary Rockwell in his
Stockbridge, Massachusetts,
studio.

Rockwell poses with table
still life.

Table and chairs from the
Horn & Hardart Automat,
New York City.

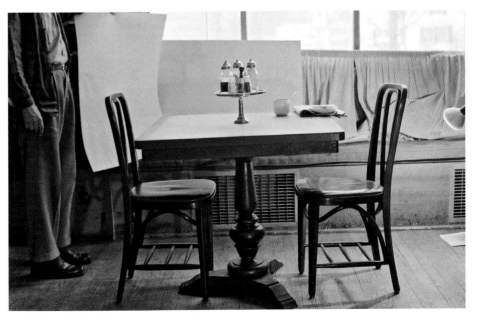

Here is Austin Briggs's approach to character development in his art. "My first step is to find the person who seems to fill the role most naturally. The more closely I can cast a character, the more likely my model is to understand the situation and the problem. She will react to the situation emotionally far more accurately than I could ever direct her to react. Her appearance, her pose, her facial expression will all be real, honest, and convincing." Briggs believed that artists should take their inspiration from real-life situations, real people acting out actual emotions rather than relying on their imaginations. He said, "If [the artist] lets the subject itself, taken straight from nature, dominate his thinking and planning, his picture is bound to have a fresh and novel approach. It will be filled with seeming 'accidents'—unique, authentic touches which will contribute a feeling of genuineness and conviction."

To illustrate a touching story about a little girl and her beloved grandfather, Briggs first had to find models who would embody the characteristics of the two people. The little girl was easy to cast, but it was harder to find the perfect person to play the grandfather. Briggs finally decided on an actor who, he said, "was the author's character personified. I could never have faked the bulk or movement of his figure without having seen him in action."

Once he had found his models, he worked through many possibilities searching for a pose that would instantly make clear the loving relationship between the two characters. But the relationship was not the only factor; the pose had to contribute movement and action to the scene he had chosen to depict. As he sketched various poses, he wanted the two figures to make a forceful composition as one unit, so that this shape would relate to all the other shapes in the design of his picture.

The pose he decided on, below left, reveals the devotion between the characters and has a beautiful, rhythmic shape. The little girl's elbow and leg repeat the form of the duffel bag over the man's shoulder,

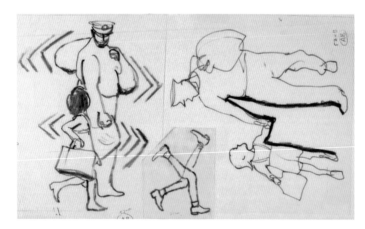

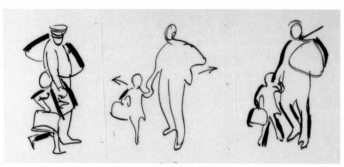

Austin Briggs
Studies and final illustration for *The Saturday Evening Post*, 1950

while her chest line echoes the man's leg action and the line of his coat to set up a contrary rhythm. Briggs wrote, "The child's legs reminded me of a pinwheel, which is synonymous with motion." It was important to the picture idea that the characters were believably moving together through the scene.

Briggs found this background for his figures in *National Geographic* magazine, in an article about the Caribbean. "The figures can now move not only through the picture space—I have also suggested space in which they can move beyond and out of the picture," he wrote. The striped doors in the composition provide interest and movement.

Although Al Parker used photography to capture characters and settings, he preferred to work from life. "I find drawing and painting from the model a real joy," he said. "When you have the person sitting in front of you, you see color qualities in the face that are lost in a photograph," he said. "Then, too, a live model during a rest period will often fall unconsciously into a position that's much more interesting

than the pose I originally had in mind." Parker used both professional and amateur models. The essential factor was the model's ability to interpret the character as the artist described it.

In choosing his models, Parker looked for individuality as well as the glamour appeal required by the women's magazines and advertisers of the day. He highlighted the unique characteristics of his models to lend variety and interest to his illustrations. If a story called for a brunette, he looked for a model with that hair color. As he said, "Then the various lights and color changes in the hair will bring truthfulness to the job." In addition to the flexibility provided by painting from the model, this approach allowed the artist to arrange props and lighting to suit the mood and composition of the final piece.

Alfred Charles Parker
Story illustration for
One Last Chance,
by Shirley Jackson,
McCall's, April 1956
Gouache on board

In Parker's illustration, a weary mother faces her teenager's room armed only with a dust mop and old-fashioned elbow grease. Despite the blank text box—Parker sometimes did not paint areas that he designated for type to save time— we sense the heaviness of the figure, who leans on her dust mop as if bracing herself for the work at hand. This clever double-page spread illustration separates the woman from the clutter by the gutter of the magazine, which would have fallen in the center of the image.

THE EXPRESSIVE FACE

Believable figures, no matter how well drawn, cannot tell a story alone. The face is a compelling center of attraction in art, inspiring viewers to laugh, cry, and empathize with the characters portrayed. Honing your powers of observation is paramount—watch people's reactions in different situations and study yourself in a mirror. One thing you'll notice immediately is that one part of the face almost never acts alone. There is always a related action from other facial muscles, for when the mouth laughs, the eyes and eyebrows become more expressive, too.

In the drawings below, Al Dorne explores a variety of animated facial expressions, from surprised to seductive. He's developed each head as a solid form in the shape of an egg that is intercepted by four convex horizontal lines—one for the eyebrows, eyes, nose, and mouth. A vertical line passes right through the center of the "egg," intersecting the forehead and dividing the eyes, nose, mouth, and chin in equal sections. Notice that the ears extend from the line of the eyebrows, and that the eyes are situated in about the center of the head. In each vignette, the artist has added details that carry weight, authenticity, and emotional content.

"The human face is a very mobile affair and can be contorted by talented muscles into mugging of an astonishing range," said Jon Whitcomb. "There are thousands of ways of showing laughing, crying, flirting, screaming, and pouting, but the same sets of muscles work in various combinations to register them all."

Whitcomb notes that a good way to explore expression is to try out a range of possibilities in front of a mirror. "In doing this you will find that various changes occur in muscle structure. In laughter, the cheek muscles become more prominent and dimples may appear. In frowning, the forehead muscles are involved and will show creases. To show doubt or disbelief, some people raise one eyebrow, and this has become a standard cliché to register skepticism."

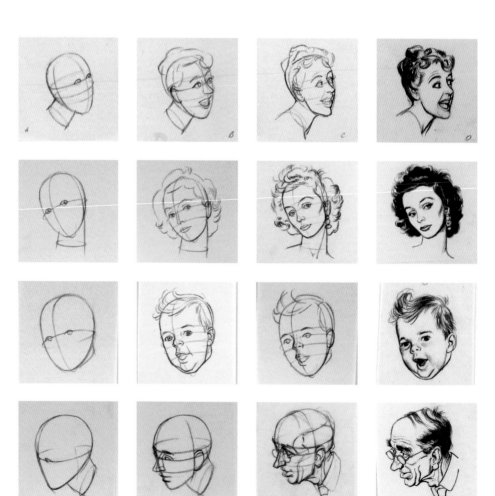

Al Dorne
Development of a face
Pencil on paper

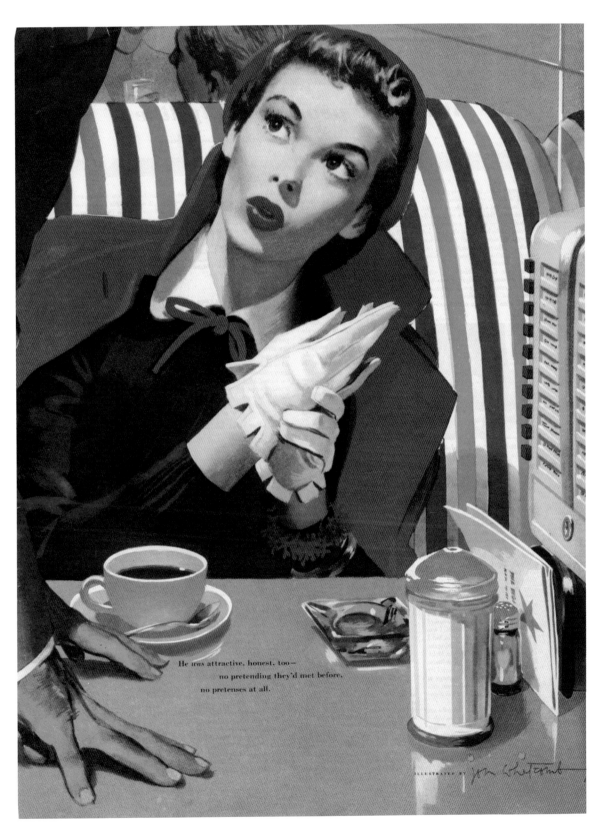

He was attractive, honest, too—
no pretending they'd met before,
no pretenses at all.

ILLUSTRATED BY *jon Whitcomb*

Jon Whitcomb
Story illustration for
The Man with 3 Faces
by Mona Williams

Disbelief

amusement

Jon Whitcomb
Facial expression studies,
disbelief and amusement
Pencil on paper

The smiling image (opposite) was the first appearance of a Norman Rockwell portrait on the cover of *The Saturday Evening Post*, published in 1952 when Dwight D. Eisenhower was the Republican candidate for the American presidency. In addition to the cover portrait, the *Post* published Rockwell's account of his session with Eisenhower, titled *The Day I Painted Ike*, which featured five portraits of Eisenhower and a portrait of his wife, Mamie.

When Rockwell arrived in Denver for the modeling session, he said Eisenhower's "eyes were far away." He thought the general might be thinking about the fishing trip he was scheduled to make after the session. In an attempt to get a smiling Eisenhower, Rockwell threw out a few remarks. The one that most changed Eisenhower's expression was, "How are those grandchildren, General—pretty nice, eh?" It was the smile after this remark that Rockwell captured for the cover. The two men continued talking, first about painting—Eisenhower dabbled in oils—then about the imminent fishing trip. The conversation eventually turned to the presidential campaign, which elicited a completely different reaction, published with this caption: "The campaign? Instantly, he was deeply serious. No punch-pulling for him! He'd rather lose the election than not tell the people just what he thinks." No matter how famous his subjects, it was not unusual for Rockwell to coach and coax his models to elicit the reactions he was seeking. A full range of expressions was quickly captured in photographs that served as his visual reference.

Norman Rockwell
Portraits of
Dwight D. Eisenhower, 1952
Illustrations for
The Day I Painted Ike,
The Saturday Evening Post,
October 11, 1952
Oil on canvas

Of the neighbors and friends who became models for Rockwell's illustrations like *The Gossips*, the artist said, "I look at my neighbors' faces and I drool. Rembrandt would have gone wild with joy at them." The expressive qualities that Rockwell admired are reflected in the animated faces of his Arlington, Vermont, neighbors, who pass along and elaborate upon a bit of hometown news. His composition draws a diagonal line from the top-left corner of the composition to the bottom right—the woman who starts all of the trouble gets caught in the end by Rockwell himself. *Post* editor Ben Hibbs assumed that Rockwell exaggerated for effect, but in examining his reference photographs, found that his painting did not stray far from reality.

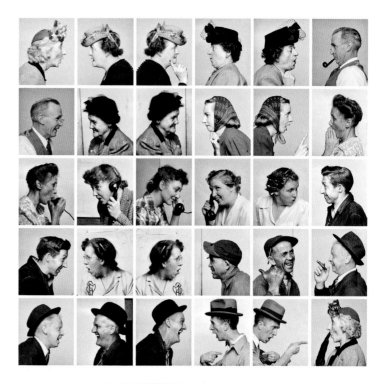

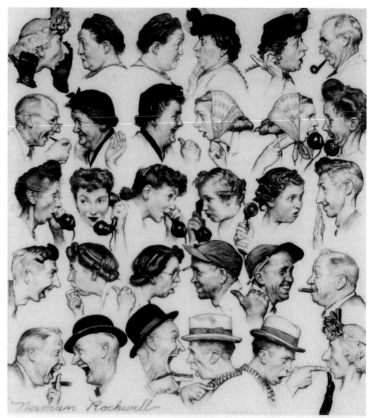

(*Top right*)
Gene Pelham
Photographs for
The Gossips, 1948
Cover illustration for
The Saturday Evening Post,
March 6, 1948
Photomontage by
Ron Schick

Norman Rockwell
(*Right*)
Study for
The Gossips
Charcoal on paper

(*Opposite*)
The Gossips, 1948
Cover illustration for
The Saturday Evening Post,
March 6, 1948
Oil on canvas

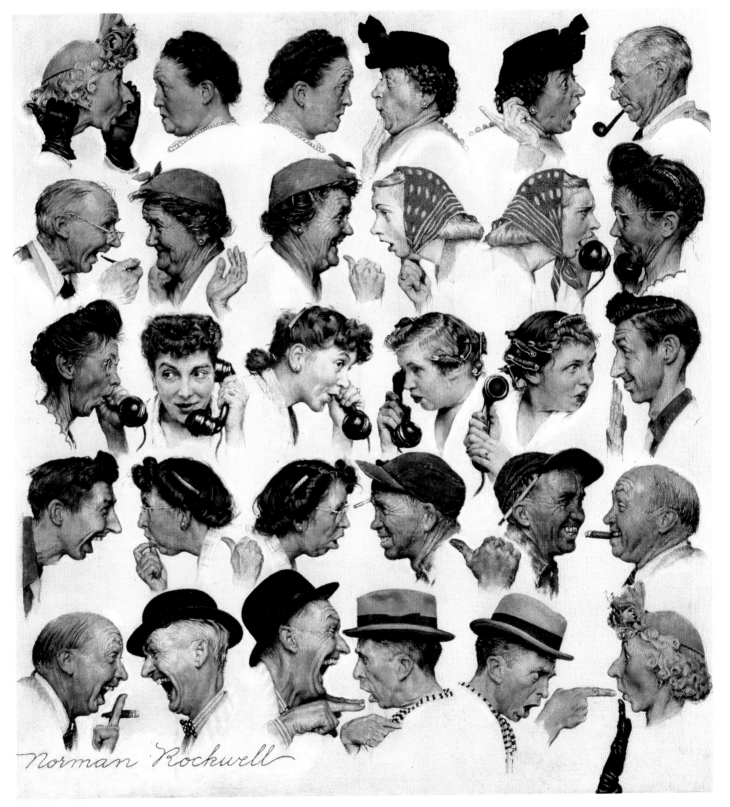

Norman Rockwell

Austin Briggs
Studies of a seated man
Charcoal on paper

Austin Briggs noted of this sketch of a man's face: "This tells the emotion." Although the figure in the full drawing is tense and ready to spring into action, the drama is indeed concentrated in his expression.

Study, Two Women Talking
Pencil on paper

In this drawing, Briggs has captured emotion and expression not only on the faces of the central characters but also on those of the ancillary figures in the background. The artist uses diagonal lines to establish the appropriate scale and perspective of supporting characters that are assembled around, but not engaged with, a lively conversation between two friends.

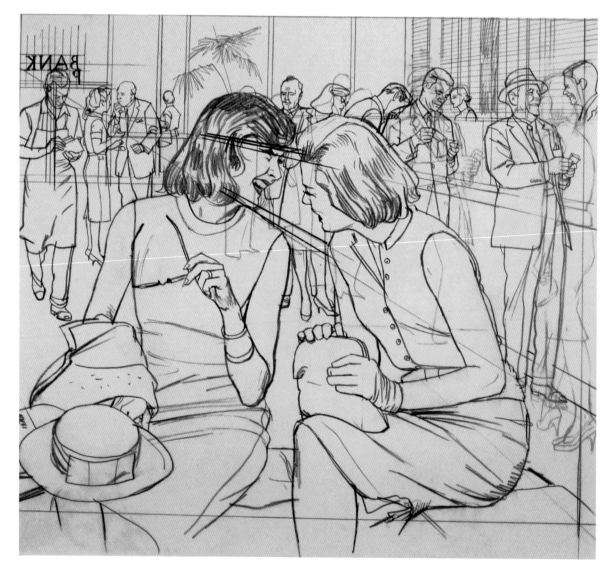

(Both images on this page)
Alfred Charles Parker
He Raised His Glass and Filled Her with Horror

When Al Parker composed this illustration, he arranged all the elements so that the girl's face would be the center of interest. He said, "I isolated [her] face by keeping the background dark against her black head covering. No matter how busy the arrangement below, you look at her first. . . . The expectancy in her face is one of horror mixed with determination to carry out her plan [of poisoning the man]."

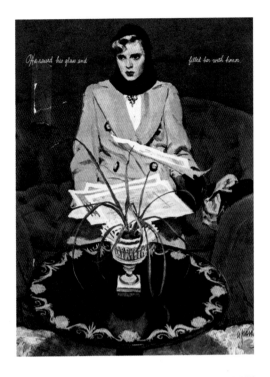

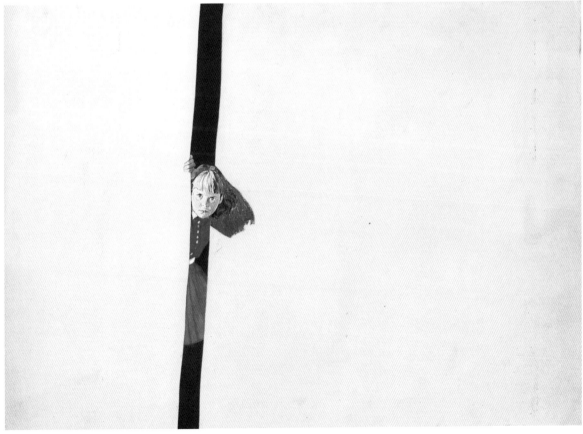

Stevie, 1956
Illustration for *Stevie*
by Norman Struber
McCall's,
January 19, 1956
Gouache and collage
on board

In this compelling work, a young girl pokes her head out of an artfully designed visual crack in the composition. She stares intently at a reality that lies beyond the page. The intensity of her gaze, bright blue eyes, and strong cast shadow call attention to the only part of the child that we fully see—her face.

(*Both images on this page*)
Robert Fawcett
Fortune Teller and Gunman
Pencil and colored pencil on paper

Here, Fawcett portrays a gunman threatening a fortune-teller. The defiance in her expression and the menace in the face of the figure moving in from the left tell the story without the need for words.

Soldier and Onlookers
Ink and gouache on board

The expressions and attitudes of the onlookers in this Robert Fawcett illustration tell us that something momentous is happening, even before we notice the gun in the soldier's hand.

Al Dorne
Facial Expressions
The Head and Hands,
Famous Artists Course,
Lesson 5

Al Dorne observed that
a sneer and a look of
disdain are both indicated
by an upturned and
averted face, with eyelids
partly closed, and a twist
of the mouth to the side,
or pointing down.

NOW YOU TRY IT!

—

STUDYING FACIAL EXPRESSIONS

Choose one subject—whether a friend, family member, or colleague—whom you can observe over the course of several hours. Request permission to photograph him or her throughout this period.

- Observe and carefully document a range of facial expressions that occurs naturally, from subtle to dramatic, much as the illustrators of the Famous Artists School have done.
- Capture your subject's expressions in simple, candid reference photographs taken with your digital device or with any camera.
- Use these photographs as the basis for a series of line or tonal drawings that examines the unique qualities of your subject's face in animated motion —whether calm, amused, pensive, tense, agitated, or more. Consider the ways in which facial features react as a whole when expressing emotion.

HANDS, GESTURES, AND BODY LANGUAGE

How does the body communicate in art? As important as facial expressions are, their impact is enhanced and carried forward by the expressive gestures of the hands and body—by the "language" of the human form itself.

In the sketch below by Austin Briggs, additional details are not necessary to give us a sense of what is going on. It seems abundantly clear that this figure, perched on a rocky incline with one arm thrust into the air and the other set for stability, is in trouble and asking for help. In contrast, spontaneous flowing lines capture the attitudes of the figures in the rough sketches shown opposite, created in pencil and ink, communicating a sense of relaxation and languor.

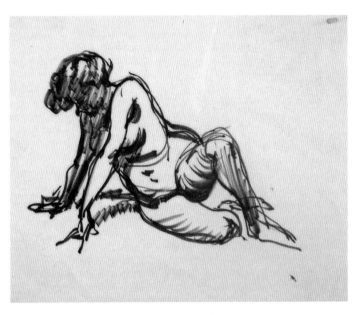

(All images on this spread)
Austin Briggs
Figure studies, c. 1948
Pencil and ink on paper

(Opposite)
Figure on rocks
Ink on paper

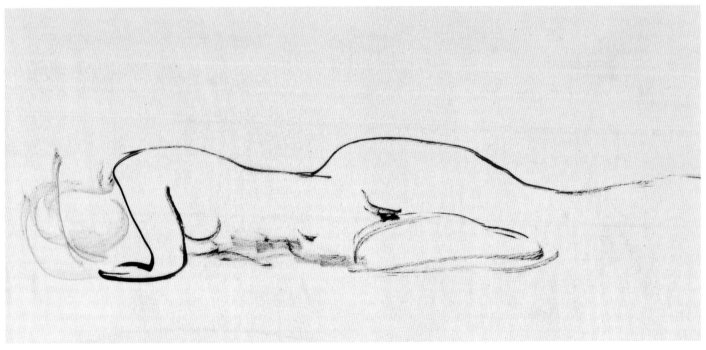

In these Austin Briggs studies, the casual body language of the men in the group at right gives a sense of ease and congeniality, whereas the stances of their younger counterparts, below, infer tension and separation.

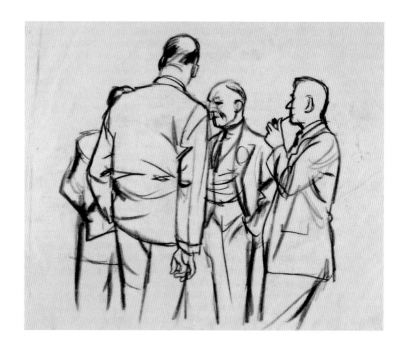

Austin Briggs
(Above)
Figure studies
Men Talking
Charcoal on paper

(Right)
Figure studies
Young Men in Group
Pencil and colored
pencil on paper

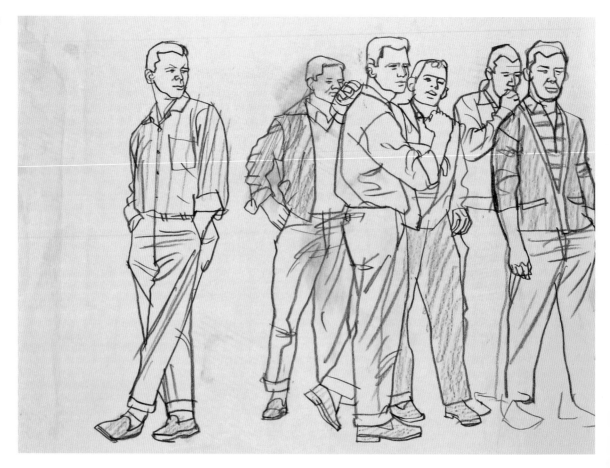

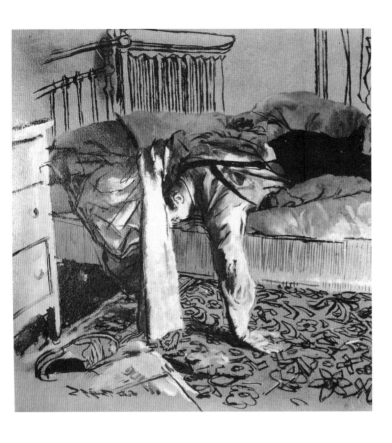

A *Matter of Life and Death*
Study (*left*) and final (*below*) illustration for
Cosmopolitan, June 1947
Oil on board (final)

When Briggs accepted this assignment, the art director
wanted him to illustrate the subtitle of a fiction story that
read, "He could not remember clearly what happened;
but one thing was starkly plain: a man had been killed,
and soon the police would be looking for the murderer."
Note the heaviness of the figure and the weight of the
arm and overturned hand, which seem to weigh the
lifeless body down. "The flat horizontal of the figure in
a calm state in itself suggests no movement, although
a sleeping figure might well have an arm over the side
of the bed as I've painted it," Briggs wrote. "I wanted to
make very sure the figure could not move and accented
the vertical of the arm with the repeated line of the bed
covering at right."

A matter
of **LIFE**
and
DEATH

The buzzer woke him up. He opened his eyes, but he did not move, and he did not try to think beyond the sound. Someone was downstairs, in the black and white foyer, using a heavy thumb on the button beside the card, that bore his name. Someone would get tired and give it up and go away, and he could get things sorted out in his mind. There was a busy, little aching merry-go-round up there in his head, and it wouldn't hold still. It was hard to think about merry-go-rounds while someone worried the buzzer.

"Go away," he told the buzzer silently.

The blinds were up; there was winter sunlight in the room. That was a starting point. A man could consider sunlight and not disturb the ache in his head. Sunlight was man's best friend. It fell on the rich and on the poor, and on the dusty carpet beside the bed. Not a lot, but what could you expect in a place like this—fifty bucks, OPA ceiling price? He watched the sun-

light, and tried not to think about the things that happened to a cost expert when he fought with the one woman in the world and fell off—dived off—the wagon. The buzzer stopped and then began again, as insistent as a dentist's drill.

Sunlight made the grass green and your hide brown. It could tell you the time of day. A watch could tell you the time, too. His watch was on his left wrist, but he didn't bother to lift it to the level of his eyes. The bedroom window looked out of the west wall of the building; the square of sunlight lay in the center of the room, well away from the sill. So it was afternoon, Friday afternoon. And that was close enough.

The buzzer had stopped; the apartment was heavily quiet. He could hear the sound of his breathing, the slow pounding of his heart. Then, quite suddenly, he was sweating and afraid. There were things in his head he didn't want to remember. He saw the dead man, face down on a rumpled bed. He saw the

He could not
remember clearly
what had happened;
but one thing was
starkly plain:
a man
had been killed,
and soon the police
would be looking for
the murderer

A COSMOPOLITAN
SHORT
MYSTERY
NOVEL
BY JOHN AND WARD HAWKINS

ILLUSTRATED BY AUSTIN BRIGGS

66
67

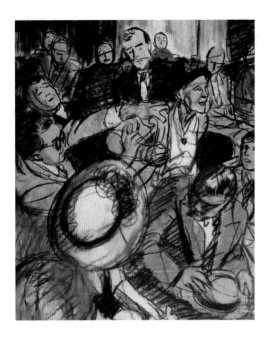

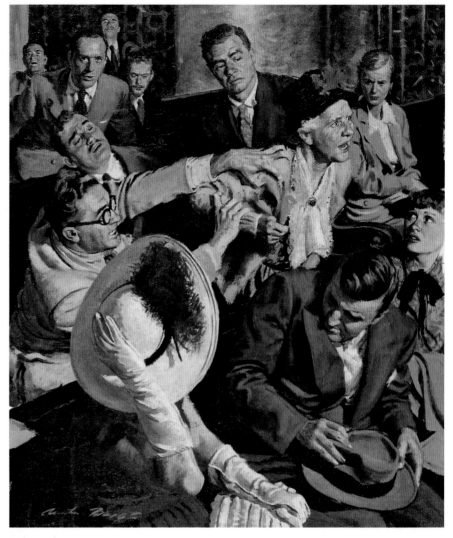

Austin Briggs
"I've come from Cat Track Holler to talk to you boys.
I want you to earn your pay and hark me!"
Story illustration for *The Six Strangers,*
The Saturday Evening Post
Study, charcoal and pencil on paper
Final painting, gouache and pencil on board

In this color sketch, Briggs uses the gestures of his
figures to bring a crowd scene to life as a woman makes
her way through the masses, undeterred by the man
who tries to hold her back. Notice how expressive the
hands of the central characters are.

Jon Whitcomb
Hand studies
Ink on paper

Of hands, Whitcomb wrote: "Next to faces, people seem to notice hands most in illustrations, and there is a widely
held belief that hands are a better indication of character than faces." Of course, in Whitcomb's case, most of his
illustrations involved men and women with impeccably groomed hands. Note the careful arrangement of the graceful
fingers in these studies—they are strong graphic elements that convey the character and status of his subject.

Jon Whitcomb
Story illustration for
with *Marriage in Mind*
by Janet Adams,
McCall's, July 1954

"You can express any human emotion with hands," Rockwell wrote. "In my picture, *Freedom of Worship*, I depended upon the hands alone to convey half of the message I wished to put over." In Rockwell's painting, hands help convey the unique qualities of each individual in great detail. A masterful technician, Rockwell advocated for learning to draw hands well, noting that "there is a saying that you can tell how good a draftsman an artist is by the hands he draws and there is some truth in this.... Hands are difficult to draw and paint but you will be well repaid for all the time and effort you put into doing them well."

For Albert Dorne, drawing hands was, perhaps, his favorite part of making an illustration, and he was known for the exceptional hands he created. He drew hands with great personality and character, and often used them to convey the narrative of a story. In the studies opposite, we see how Dorne animates his story illustration with articulated arms and hands, indicating volume with concentric ovals and exaggerating reach and movement for special emphasis.

(*This page*)
Norman Rockwell
Freedom of Worship, 1943
Illustration for
The Saturday Evening Post,
February 27, 1943
Oil on canvas

(*Opposite*)
Al Dorne
Studies [hand] for
illustration for
The Kid's in Town
by Charles Einstein,
Collier's, January 10, 1953
Studies, pencil on paper

The Kid's in Town

BY CHARLES EINSTEIN

If Hollywood wanted authenticity, we'd give them all they could stand. We'd ambush 'em, shoot 'em up, cut 'em off at the pass. After all, we're not in the movie business just for laughs

46

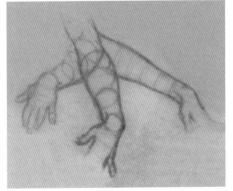

Al Dorne
Figure studies,
Pencil on paper

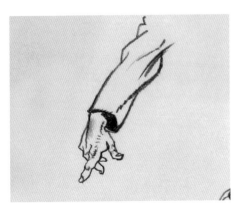

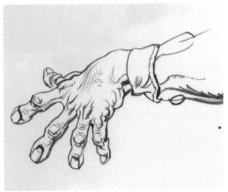

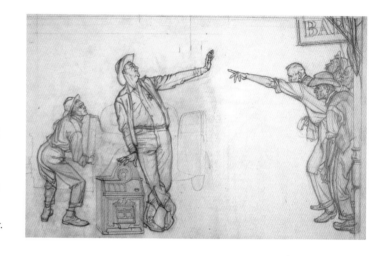

As an acute observer of human physiognomy and individuality, Dorne created memorable characters whose body language was both amusing and compelling. Note his method of drawing clothing over the structure of the figure, which is revealed beneath.

Dorne believed that "if you have mastered the craft of drawing, you are on your way to making good pictures." He used strong outlines to emphasize a figure's silhouette and diagonals to describe form and volume, as in the folds of clothing that emphasize the anatomy.

(All images this page)
Al Dorne
(Above, near right, and far right)
Figure studies, c. 1948
Pencil on paper

(Below left)
Advertising study
Pencil on paper

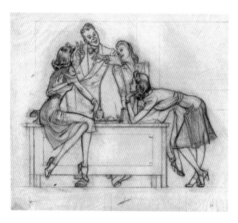

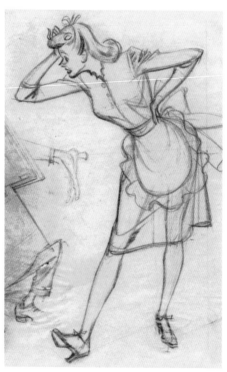

The drawing of a boy leaning in with hands on knees (opposite) is well proportioned and recognizable as a child—his head appears larger than that of an adult in relation to the rest of the body. According to the Famous Artists Course: "At the age of four, the child is about half the height of an adult. At the age of twelve, about three quarters the height. As the child grows older, the size of the head, in relation to the trunk, changes. At the age of twenty-five, the figure is full grown."

The information-filled page from the Famous Artists Course, below, outlines a four-step process when drawing hands:

Step 1: Spacing and Placing. Sketch in the action and approximate the area of the hand, loosely capturing each part as it appears.

Step 2: Solidarity of Construction. The block method of drawing the hand, utilized by Norman Rockwell's anatomy teacher George Bridgman, defines the planes and surfaces of the hands and fingers.

Step 3: Details. Carefully draw the details of the hand and fingers, erasing the marks from steps 1 and 2 as you proceed.

Step 4: Planes of Light and Shade. Observe and capture areas of light and shadow on the hand's form, being careful not to lose the forms already delineated.

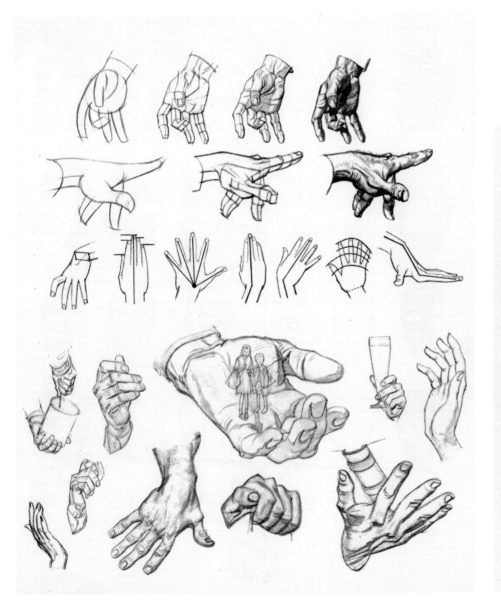

NOW YOU TRY IT!

DRAWING THE HAND

The Famous Artists Course advised students to see, observe, and remember as they drew. Use the methods above to study and draw a hand from life, either a model's or your own.

- Capture its position with a quick sketch.
- Block in the top, side, and bottom planes of the hand and fingers.
- Draw the details of the hand, such as folds of skin and indications of bone structure beneath.
- Notice and indicate how the light that is cast upon your hand also creates shadows. Emphasize the contrast of light and dark to establish a sense of volume and form.

THE FIGURE IN MOTION

"Whenever possible," wrote Austin Briggs, "I study the action or activity I am illustrating, so that I can be sure my characters look and move as convincingly as possible. . . . Suppose you are planning to draw a picture of men planting a tree. It would be easy to fake the action, of course. But it is much better to go out and watch men doing the job. Then you will know much better how it is done, and you will have a much better chance of finding an interesting and provocative approach to the subject."

Briggs also saw the value of drawing the figure in total, even if just a portion of it appeared in his final illustration. He planned to use the pose below for a partially hidden figure, but felt it was "essential to draw the whole . . . so that it would be soundly constructed from the ground up."

Natural, convincing action is yet another key to successful illustration. Viewers must be able to "read" the story or incident with one quick glance at the figures in motion. If they look awkward—or, worse, unrealistic—the impact of the illustration is lost.

The founding artists often worked from photographs to achieve as much authenticity as possible. As Austin Briggs said, "If . . . you are portraying an action scene, make sure you photograph your models actually in action. It's nearly impossible to predict what will happen to clothes—or to the body either, for that matter—in real action."

Norman Rockwell embraced that method of working, as illustrated in *Liberty Girl*, a determined World War II worker who is ready to take on any task. In both Rockwell's photograph and his drawing (opposite), the model is propelled forward in motion, and her

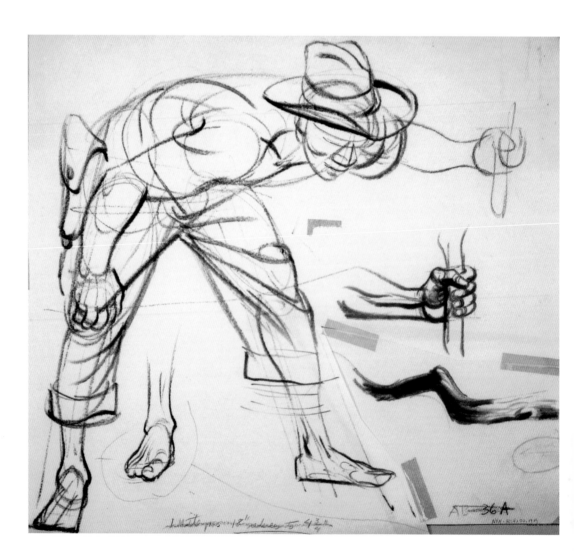

Austin Briggs
Man Planting
Ink on paper

In this drawing, Briggs captured the gesture of his subject and made separate, more detailed studies of a hand holding a branch, and of the branch itself, to depict visual information. Briggs's bending figure is "drawn through" with lines that encircle the body, emphasizing volume and the form beneath his subject's clothing.

right upper arm echoes the position of her angled back. Note how Rockwell propped up his model's leading foot on a shovel to emphasize the idea that she is in motion. This was a frequent approach for the artist, who also used books to raise his models' heels and toes to create an exaggerated sense of movement.

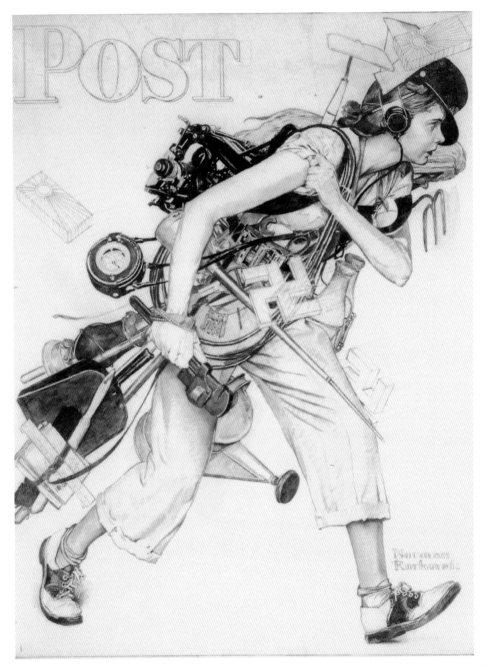

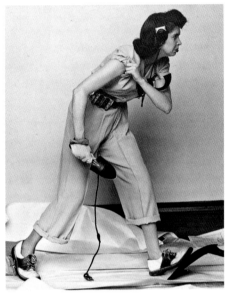

Norman Rockwell
Liberty Girl, 1943
Photo and cover study for
The Saturday Evening Post,
September 4, 1943
Charcoal on paper

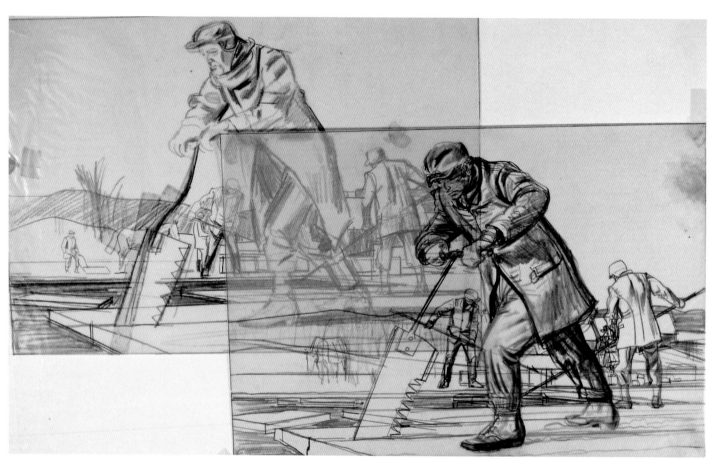

Robert Fawcett
Advertising studies for *Ice Cutter*
Charcoal, pencil, and conte crayon on paper

In this series of studies portraying a nine-teenth-century New England ice cutter for an advertising illustration, Robert Fawcett emphasized motion and effort by capturing his subject in mid-cut, bracing himself for the forward-leaning effort. The artist used tracing paper to modify and refine the movement of the figure in a layering technique that retained his overall intention while allowing him to make subtle changes. Note the differences in arm, hand, and leg positions and, most especially, the angle of the man's head, which is tilted downward in his more refined drawing to emphasize his focus on his work.

Al Dorne
Magician
Pencil on paper

Here, Dorne employs carefully chosen details in order to animate his subject. This magician has just taken the iconic pose of the conjurer about to make something appear from the hat on the table. The swing of his cloak, the folds in his sleeves and trousers, even the position of his hand, all alert us to watch closely to see what will happen next. The diagonal of the magician's extended leg flows into his angled torso and head to create a sense of movement and drama.

NOW YOU TRY IT!

—

CAPTURING FIGURES IN MOTION

Take a sketchbook and some drawing materials to a public space, such as a park, shopping mall, or museum filled with people in dynamic motion. Capture the essence of one or more figures, whether walking, jogging, or engaged in animated conversation, by quickly sketching action lines representing their positions and gestures.

- Focus on the sweeping direction of their movements, rather than anatomical detail, by creating simple line studies.
- Choose the drawing that most successfully captures movement, and gradually refine and build upon it by adding volumetric form and tone. Be sure to retain the qualities of movement and spontaneity that were originally evident in your work.

7 AN EYE FOR COLOR

In the eyes of the Famous Artists, color—unlike the more tangible elements of line, form, value, and composition—is greatly dependent upon imagination, ingenuity, and taste. Color's creative uses, as well as thoughts on what color is, how to organize it, and how to employ it for greatest impact, are considered in this chapter.

Jon Whitcomb
Boy at Party
Cover illustration for
Good Housekeeping,
March 1940
Gouache on board

Color, said Peter Helck, is personal to each individual artist. "You may feel an instinctive love for the sensuous richness of exotic color —pungent deep-toned reds and oranges, hot greens and mellow earth hues. Or you may feel in perfect accord with the cool grays, greens and blues such as you encounter on a hike through the hills on a misty, sunless spring day."

That said, artists make color choices not just based on instinct but also with knowledge of the effect that colors have on one another, and on the mood and message of their work. A festive, happy scene requires bright, high-key colors, as in Jon Whitcomb's image of a birthday celebration and the enthusiastic youngster being served an ice cream sundae by an unseen figure (page 126). More somber subjects are better communicated with low-key neutrals and quiet tones.

Before learning when and how to use color to best effect, it is important to understand three important dimensions: *hue, value,* and *intensity.*

Hue is the term we use to name a color. Yellow, blue, green, violet, red-orange, and so on, are different hues. When artists speak of "warm" and "cool" colors, they are referring to variations in their hues. In general terms, any color can be warmed by adding yellow, or cooled by adding blue—two essential primary colors.

Jon Whitcomb
Boy Reading
Cover illustration for *Good Housekeeping,* January 1941

In this portrayal of a young boy reading, Whitcomb utilizes a palette of black, white, and gray accented with red, which brings attention to his subject's face.

Value is the lightness or darkness of a color. Artists look at their subject and decide which area is lightest and which is darkest. The other areas of an artwork will be related to these two extremes and must be carefully controlled so that the desired effect is achieved.

Intensity refers to the strength or purity of a color. Colors straight from the tube are of maximum intensity, but it's rare to use them that way. Rather, in order to create a range of subtle and varied colors, artists use black, white, gray, or a complementary color to weaken intensity.

The color wheel, a diagram of primary, secondary, and tertiary colors, was first designed in 1666 by English physicist and mathematician Sir Isaac Newton (1642–1727). Colors across from each other on this circle of hues, such as red and green, are called *complementary colors* and are most unlike or opposite each other; they can be combined to create a sense of vibrancy and visual excitement. Those next to each other on the color wheel, such as blue and violet, are *analogous colors*; they are more congruous and can be combined to create the impression of harmony or a sense of calm. The *primary colors* of red, yellow, and blue cannot be created by mixing other colors. The *secondary colors* of green, orange, and purple are created by mixing two primary colors. *Tertiary colors* are made by mixing a combination of primary and secondary colors.

Al Parker said, "Color is a game—have fun with it!" However, he also cautioned that artists must have a plan for color use. Your feeling for color may be instinctive, but balancing hues, values, and intensities to get the result you want requires planning.

Alfred Charles Parker
Always with Me, 1942
Story illustration for *The American Magazine*, July 1942
Gouache on board

Al Parker's *You're Always with Me* is designed to convey harmony and connectivity, both in the intertwined postures of the couple and in the choice of colors. The dominant red and blue are in close proximity on the color wheel, and each is used in different values and intensities within the composition. For example, the color of the man's bright blue jacket appears in a softer, less saturated variation in the wallpaper, a unifying element. The woman's shoe, the stripe of her shirt, and her lips are the same red hue, moving attention toward the most important center of interest—her face.

The founding artists advised students to train the eye by carefully observing the variations of color in nature and the environment, and becoming familiar with the effects of different kinds of light. For example, notice the color differences in the two paintings on this page. In the first, the barn casts a cool, bluish shadow over the fence and farmer at a transitional time of day. Only parts of the grass, rocks, and tree are struck by direct warm sunlight. In contrast, a second version of the same scene shows how it would look in direct sunlight. To create this effect, you would use warm colors such as red, yellow, and orange in the light-struck planes. The shadows contain cool blue and violet tones.

(All images on this spread)
Artist unknown
Famous Artists Course
Color studies
Acrylic on canvas

Below are other examples of the effect of warm and cool colors—and, thus, the effect of light—on an outdoor scene. For the first version, to create a sunny effect, yellow was mixed into other colors on the palette. The top row of colors shows the pure pigments; the bottom row shows how they look with a bit of yellow added. In the middle painting, depicting an evening scene, the artist added a small amount of blue. Again, you can see the differences in the two rows of hues. Finally, the artist added gray to each color to produce a cloudy or rainy effect.

NOW YOU TRY IT!

—

SAME SCENE, DIFFERENT TIME OF DAY

Working from life in any color medium of your choice, identify a scene that you can study in two distinctly different kinds of light—whether early morning, midday, twilight, or night. The image can represent nature, as in the artworks below, or be drawn from a more urban or domestic setting featuring objects, buildings, or people bathed in light.

- Carefully observe your scenario at different times of day, making simple color notations for each without focusing on the creation of form. These should represent both the dominant colors in the scene as well as those in a supporting role. Notice the pattern of light and shadow that falls across your setting, as well as areas that are warm and cool.
- Using two identically sized papers, canvases, or boards, sketch in your scene on both.
- Working directly from observation, mix colors to represent the given time of day. Bear in mind that, as demonstrated in this section, yellow warms colors and blue generally cools them.
- When your artworks are completed, place them side by side to see if they truly represent the unique qualities of light and color observed at different times of day, and adjust as needed.

Famous Artists Course
Color studies
Acrylic on board

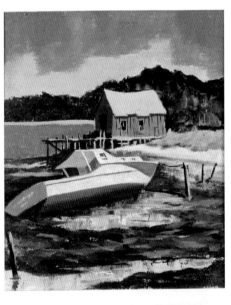

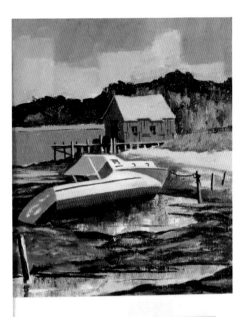

MAKING COLOR CHOICES

Whenever you use one color in a painting, it will always be affected by the colors around it. Painting is actually a process of making constant adjustments of hue, value, and intensity.

In the two stages of the still-life painting (below and opposite), we see the subtle choices that the artist made to give each object its local color—an object's natural color without the effects of light, shadow, and reflection—while maintaining harmony and visual cohesiveness among all the elements. In the earlier stage, areas of color, light, and shadow are defined. In the final version, highlights and reflected light have been added, and the wall has been grayed to keep it in the background.

(*Both images on this spread*)
Artist unknown
Color studies
Famous Artists Course
Acrylic on board

Here, we see the available color options in creating a successful rendering of a landscape photo. Before starting to paint, the artist carefully noted where the strongest yellows and oranges were, the variations of greens, and the receding colors of the distant mountains. The final painting reflects these skillfully observed colors, as well as the simplification the artist felt would improve the picture.

(Both images on this spread)
Artist unknown
Color studies
Famous Artists Course
Acrylic on board

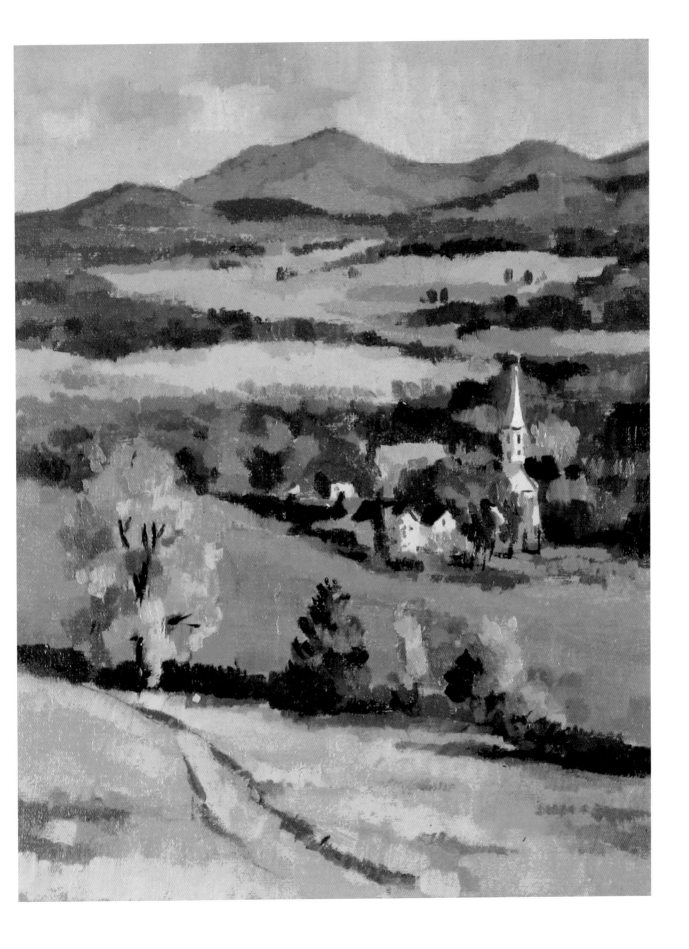

Al Parker planned his color schemes in advance. He said, "An illustration in color does not have to be lush as a rainbow to be effective. I usually play up one, two, or three colors, leaving other colors to back up my composition."

In the illustration below right, Parker used variations on the color green and its complementary (or opposite) color, red, throughout the composition. Touches of yellow and soft browns lend unity and support to the principal colors. "I quite often make a black and white sketch before doing a color composition," Parker wrote. "I use it as a guide to keep the colors in their proper values."

On the opposite page, Parker has narrowed down his palette even further. The large expanse of white, which serves to focus our attention on the face of the recumbent woman, is surrounded by a cool array of blues and greens. A few touches of red and yellow keep the color scheme from being too monotonous and connect the three women in the scene.

(All images on this spread)
Alfred Charles Parker
Man Reading on Couch Glancing at Woman
Pencil sketch and final illustration

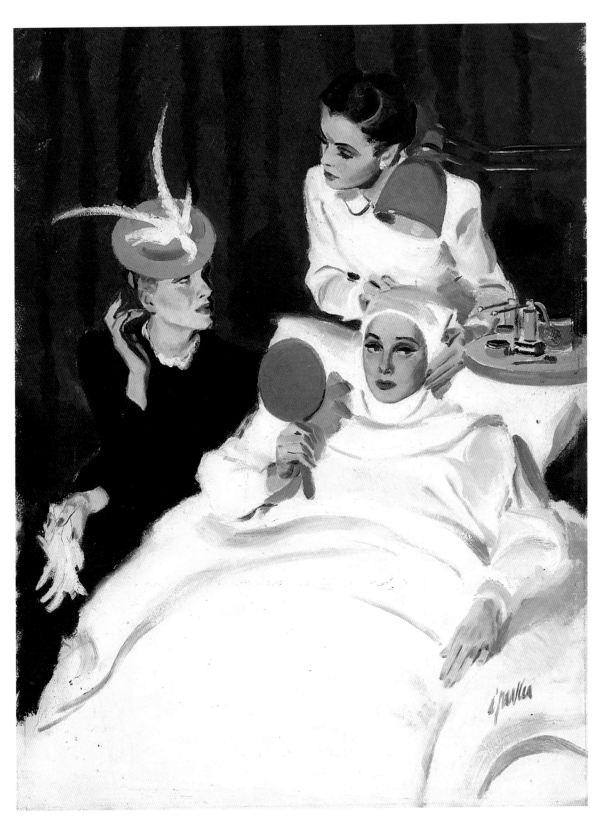

What Makes a Glamour Girl?, 1939
Illustration for
If Love I Must by
Katharine Newlin Burt
Ladies' Home Journal,
July 1939
Oil on board

(*All images on this spread*)
Jon Whitcomb
The Affair, 1948
Study for *The Affair*
by Elise Jerard,
Cosmopolitan, July 1948
Gouache on board

Of his color choices in
this illustration study,
Whitcomb wrote
"Rendering colors for
night scenes involves
considerable lying,
especially in scenes like
this, in which moonlight
ostensibly provides the
only illumination. Actually,
only pale blues are visible
under such conditions."
Whitcomb added the
other colors to fulfill what
the viewer would expect
to see.

*Man and Woman
in Mountain Scene*
Gouache on board

In this scene, Whitcomb
said of the girl's attire,
"I gave her a yellow
sweater, a yellow hood,
and a yellow skirt, which
. . . made a horizontal
contrast to the vertical
feeling I wanted to give
the mountains."

Whitcomb faced a difficult challenge when creating the story illustration, below, featuring a hooded woman glancing out at the viewer—the image would be printed on two pages, but only the right-hand segment would be published in full color. The left-hand page would be printed in two colors, black and red. The artist came up with a solution that allowed him to spread the figure over both pages while still operating within these color requirements. In his final painting, only the black scarf appears on both pages, with all other variations to the right. To heighten the dramatic effect, Whitcomb used a mostly red and black color scheme, with just a touch of the complementary color, green, as a highlight under the girl's chin. He established the black scarf as the darkest value and the woman's eyes and earrings as the lightest, with midtones distributed throughout the composition accordingly.

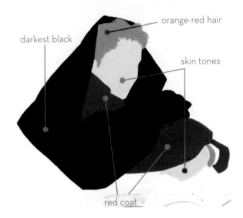

(Below)
The Girl with the
Nasturtium Red Hair
Gouache on board

Studies for *The Girl with*
the Nasturtium Red Hair
(From top):
Silhouette, grayscale,
color block, and color

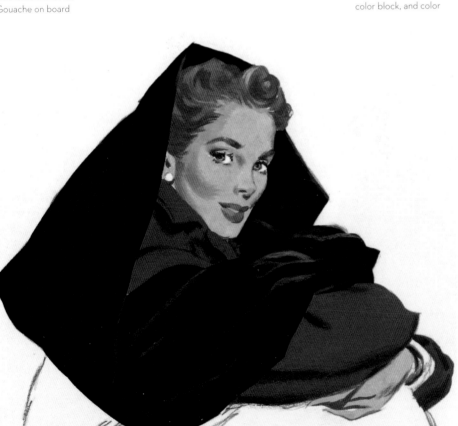

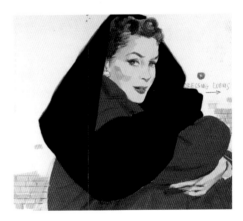

USING COLOR TO EVOKE MOOD, CHARACTER, AND ATMOSPHERE

Beginning in the mid-1930s, Rockwell created color sketches by photographing his detailed charcoal drawings, and painting in oil on top of the photo. "I usually start my color sketches by rapidly painting in the flesh tones of the figures in my picture. I do this because I find that you can let yourself go in the color of clothes, props, and even landscapes, but people must look human and believable," he wrote. "Of course, the flesh color varies with the people and lighting in your picture. Naturally, flesh in moonlight, firelight, and plain daylight is quite different but in a human interest picture it must be realistic and convincing."

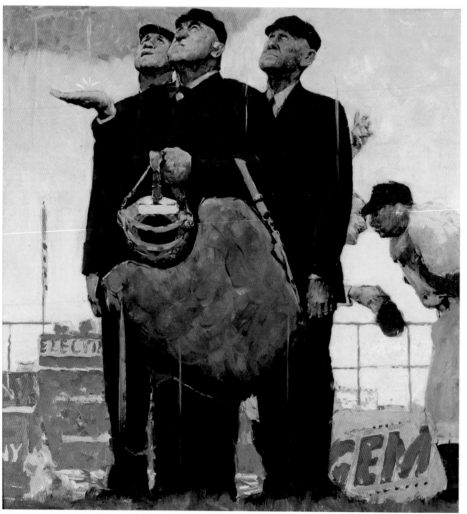

(All images on this spread)
Norman Rockwell
Game Called for Rain (Tough Call), 1949
Cover illustration for *The Saturday Evening Post*,
April 23, 1949
Study (*above*) Charcoal on paper; color study (*left*),
oil on photograph; and final illustration (*opposite*)

Rockwell established his color palette on a photograph of his original charcoal study, which served as a structural and tonal guide. Blue is the predominant color in *Game Called for Rain (Tough Call)*, which conveys a sense of overcast light and an impending storm. Warmer colors permeate the composition in both the color study and the final painting, connecting the signage and buildings in the lower portion of the picture to the gear and cloud in the upper center and left.

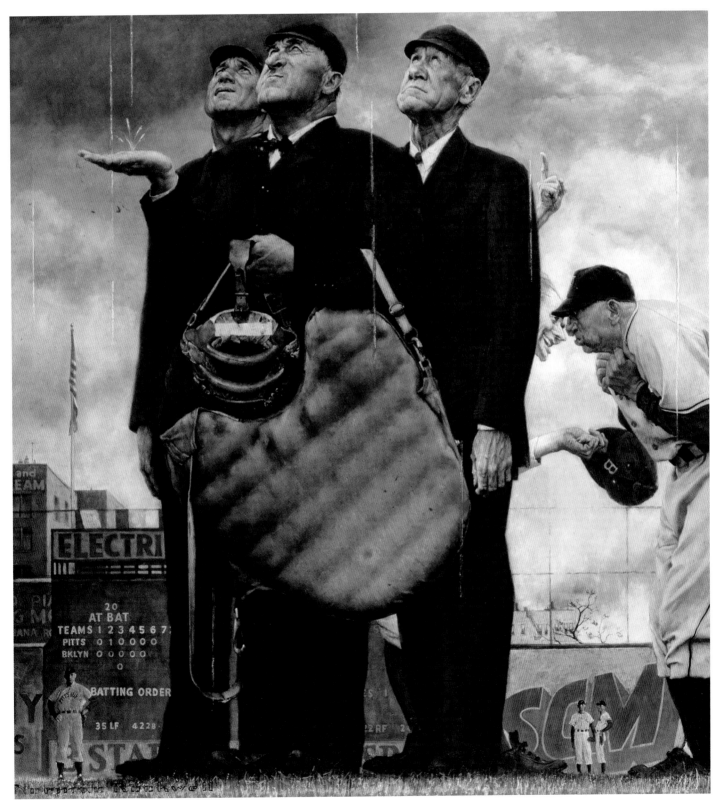

(Both images on this page)
Robert Fawcett
A Portrait Reversed [Artist in studio, south of France],
c. 1949
Story illustration for *The Saturday Evening Post*
Casein and pencil on board

In this story illustration, Fawcett used high-key colors
to evoke the warmth and friendly mood of an artist's
studio in the south of France. "I tried to keep the
studio light and airy with no gloom," he commented.
A magenta-violet light suffuses the atmosphere, linking
the composition's foreground, middle ground, and
background, and contributing to the painting's narrative.

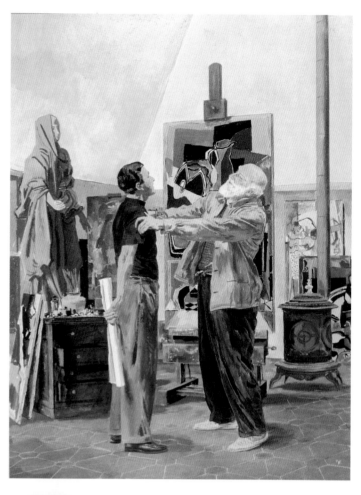

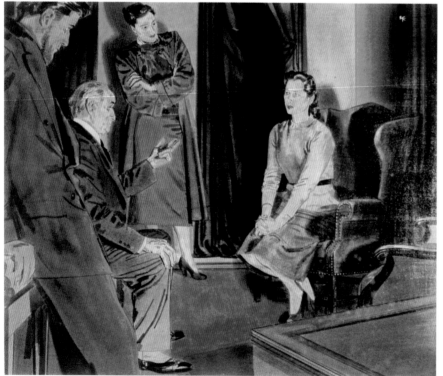

Story illustration for *The Network* by Evan John
The Saturday Evening Post, July 10, 1948
Gouache and watercolor on board

Warm but less sunny in feel, this illustration utilizes oranges
and browns to convey a more ominous mood in an insular
domestic setting. All eyes are on the seated woman, who is
clearly the center of interest here. Her face and torso are
the lightest parts of Fawcett's composition, and she is set
against her darkened shadow, cast behind her. The artist
breaks the scene's monotony by placing touches of blue
in the man's collar (left), woman's sweater (center), and
chair (right), carefully moving the viewer's eye through
the composition.

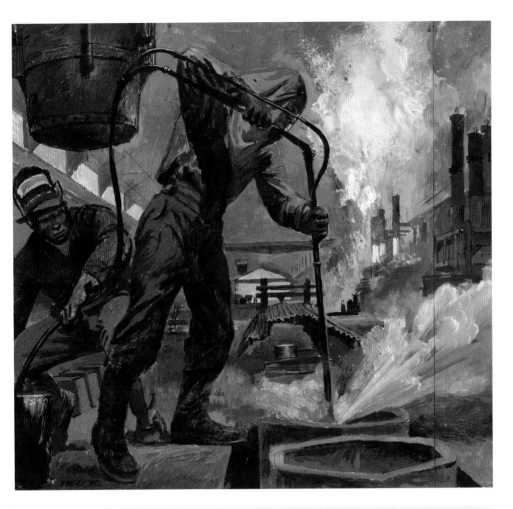

Peter Helck
Melt Shop
Pencil and gouache on paper

Helck used color to create both mood and character in this dramatic scene of men at work in the melt shop of a steel mill. While the foreground figures are large in scale, they are relatively subdued in color, being rendered in neutrals with just a few spots of the complementary colors red and green. This arrangement conveys a sense of stability and the hard, concentrated work of laborers in such a setting. For the focal point of the painting—the fiery electric furnace in the background—Helck said he wanted to bring to life "the look of smoke and fumes being subjected to the hot glow from the furnace and the vibrating cool blues and greens from the electrodes. . . . A few touches of brilliant orange and yellow . . . brushed in to silhouette the profile of the active furnace." He used cool grays to portray the jet of steaming vapor in the immediate foreground, modeling his colors with his fingertips.

NOW YOU TRY IT!
—

COLOR NOTES

Write a note to a friend or family member without the use of words by creating a message that conveys emotion through color.

- Cut six 8 x 8-inch (20 x 20 cm) squares of illustration board as substrates for this experiment.
- Choose a color medium, whether oil, gouache, or watercolor paint, or a dry medium like pastel, colored pencil, or oil pastels, with a range of colors available for direct use or mixing.
- Make a list of six distinct emotions that you may wish to convey to someone else in a color note—from love and tenderness to anger, frustration, joy, or sadness.
- Without concern for composition or form, let your mind and imagination roam free, depicting each of the emotions you have delineated individually through the use of color.
- When you are done, place your color notes side by side to analyze their differences and the part that color played in communicating emotion. Then share your notes with friends to see how they interpret what you created.

FAMOUS ARTISTS BEHIND THE SCENES: MATERIALS AND METHODS

In creating a visual language through their art, the Famous Artists employed a diverse range of materials and techniques to accomplish their goals. This section offers information about the traditional materials they kept at hand—from graphite pencils, ink, and brushes to opaque and transparent watercolor, oil paints, paper, board, and canvas—as well as specific approaches to using them.

JOHN ATHERTON

John Atherton enjoyed painting in tempera, writing that "tempera has much greater range, more possibilities, and can be worked over more readily than watercolor without losing its good qualities. It more nearly approaches oil in many respects, yet can be made to appear flat and decorative for use in posters or designs." The artist was also a master in oils and had a particular way of working, no matter the medium. One technique was to give an entire picture a wash of tone, called an *imprimatura*, before beginning to paint. His

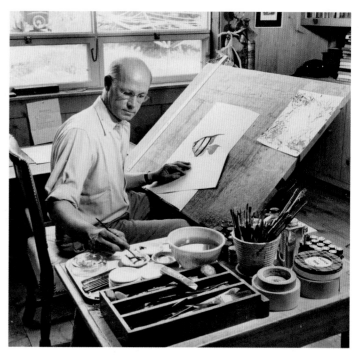

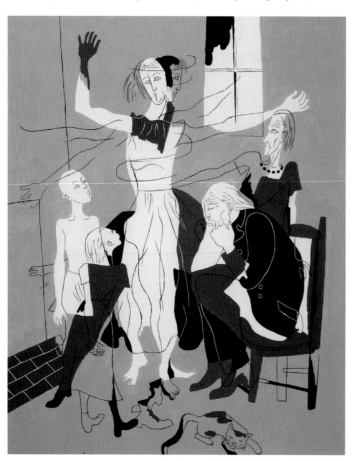

imprimatura was usually created in a warm color, such as raw sienna. This wash should never be opaque, he cautioned; rather, it should always permit the white paper to show through. "It is the glow of the white *through* the colors which gives them the life and shimmer which are sometimes so desirable," he said.

When working on an oil painting, Atherton achieved softness by using a "wet-in-wet" technique. He found that the blending of color and tone could best be accomplished with paint that was neither too thin nor too thick. He wrote, "One of the best ways to achieve smooth gradations of tone is to put on the color rather evenly, not attempting to blend it too thoroughly at first. Then, with a fairly large sable brush which is dry and clean, very lightly stroke over the surface, gradually bringing the tones together. I use a flat sable oil brush about three-fourths inch wide."

Atherton had another piece of important advice: "Know when to stop work on a picture. The picture is finished when it says completely and clearly what it should say. Anything further added is just excess baggage, so try to recognize the point where you should sign your name and put down your brushes."

John Atherton
Book illustration for *The Crock of Gold*
by James Stephens
Gouache and ink on board

AUSTIN BRIGGS

At the start of a project, Austin Briggs made many composition sketches, usually with a waxy litho crayon or charcoal. He started the painting process by drawing from those sketches with Winsor & Newton oil paint and watercolor brushes, using a color that would be one of the dominant hues in the final version. Briggs usually painted on a panel coated with gesso—a glue and chalk coating applied to a hard surface such as Masonite. The same gesso coating could also be applied to canvas. Gesso had many advantages: it was absorbent and soaked up turpentine mixed with paint quickly, which speeded drying time and allowed the artist to layer color or rework sections of the piece. Briggs observed that "the chalk in the gesso has a tendency to rub off and mix with the color being applied. This gives the resulting effect considerable luminosity and a tempera-like quality. I personally prefer this to the oily, juicy effect of straight oil applied on the ordinary ground."

During the first stages of painting, Briggs often used light washes that were almost transparent. This allowed him to preserve the under-

painting or drawing under the washes until he was sure that everything was as he wanted it. He always put in the middle tones first, to establish the local color—the true color of an object or a surface as seen in typical daylight. Then he added highlights for light-struck areas and dark shadows for areas deprived of light.

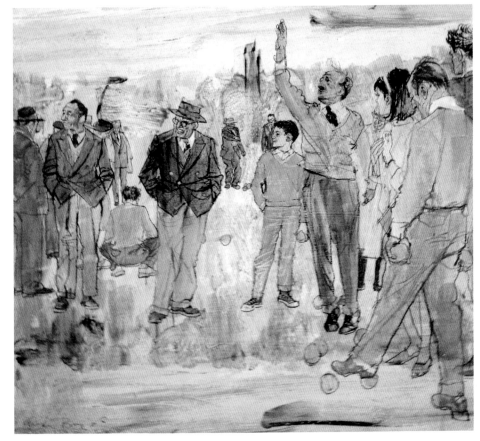

Austin Briggs
Playing Bocce
Mixed media on board

STEVAN DOHANOS

From props to paint, Stevan Dohanos prepared carefully for every illustration assignment, with meticulous research and attention to detail. When he was ready to paint, he kept his reference materials handy and his props around him until he finished the assignment. Efficient in his process and technique, Dohanos took about four painting sessions of five hours each to complete a typical illustration. He used red sable brushes (in sizes from #00 to #4) and squeezed his colors directly from the tube onto his palette. Winsor & Newton transparent watercolors were mixed in with Winsor & Newton Designers Colors, which were widely used opaque gouache paints, and casein tempera. He said, "Watercolor is the medium which I have found to be my best means of expression and most of my work has been done in it. In later years I have included tempera but, to me, tempera means just opaque watercolor." His most admired watercolorists were Charles Burchfield and Edward Hopper. In the 1960s, in a waning illustration marketplace, Dohanos painted still-life subjects featuring his collections of treasured objects like decoys, folk art, and weathervanes, symbols of American culture and craftsmanship.

Stevan Dohanos
Bird
Ink on paper with
acetate overlay

ALBERT DORNE

Albert Dorne never had formal art training. A quick study, he worked at an unpaid art studio job to acquire knowledge of business and developed his own techniques to achieve results, meet deadlines, and please clients. He started each project by creating a "comp," or comprehensive drawing. Once he had the client's approval, he would make a careful and complete pencil drawing. After transferring his image to illustration board, Dorne began the painting process, achieving striking results in record time by outlining forms in black line for emphasis and turning to colored inks and dyes. With self-deprecating humor, Dorne explained his approach: "Very early in what I like to refer to as my artistic career, I built up an immunity to complicated techniques that call for A) Reading a lot, B) Experimentation, C) Making a mess of a job because I couldn't handle the

medium, and D) Having to do the whole thing over. All of this may sound like an attempt to excuse my lack of technical knowledge. It is."

Dorne also increased his working efficiency by hiring assistants to handle the business side of his career, realizing that his time was more profitably spent at the drawing board. However, no matter how many assistants he had, he was adamant about doing all his own artwork. He spent long days at work, conferring with clients by phone, since meeting them in person would be too time-consuming. His fellow artists marveled at the pace of his work. Clippings, tearsheets, sketches, and notes collected by his assistants were kept close at hand to lend verisimilitude to any subject he might be called on to illustrate—from city scenes, which were familiar to him, to farm animals, which were not.

Al Dorne
Story illustration for
The Quarter Pound-Loss
by Hazel Heckman,
Collier's, July 19, 1952

ROBERT FAWCETT

Although Robert Fawcett considered his working methods and materials to be "eccentric," he was glad to share them with his students. For example, he wrote, "I have used very old brushes for many years. They are worn, the points are gone, but they are like old friends. Their shape and condition nevertheless impose certain restrictions upon me. They will make only fat, juicy lines, so I must think in 'fat, juicy' terms. When I buy new sable watercolor brushes, I am unhappy for a long time and invariably cut the last hairs off the points with a razor blade."

A Fawcett illustration often started out as a doodle. For these, the artist often used a ruling pen held like a pencil. Why did he prefer this implement, which holds ink in a slot between two adjustable metal jaws? "I just like the *feel* of it," he wrote. He would then wash in tone and color, often using diluted inks.

Once the basic form of the illustration was established, the drawing stage began. For this, Fawcett often used a fairly large, flat watercolor

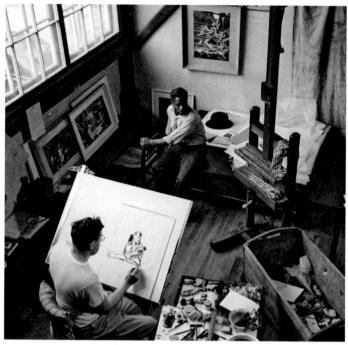

brush with a blunt point and ink that was designated as waterproof—though he did dilute it with water so that it made a dark gray line. For painting, he preferred flat sable oil brushes, 1 inch (2.5 cm) wide and well worn, sometimes with long hair. Fawcett liked his painting brushes to have long handles so that he could stand well away as he was working, to be able to see the design more clearly. He felt that he achieved his most successful results when following a technique used by the Old Masters, who "glazed color over a black and white under-painting until they had all the richness they desired, then articulated with opaque tempera or oil the spots which needed clarification."

Robert Fawcett
Story Illustration for
*How a Secret Deal
Prevented a Massacre
at Ole Miss*
by George B. Leonard,
T. George Harris, and
Christopher S. Wren,
Look, December 31, 1962

PETER HELCK

As shown (right), Peter Helck worked with a mahlstick—a long wooden implement used to steady his hand as he painted standing up. Often balanced on a painting's edge, a mahlstick is useful when painting detail or when an artist needs to avoid touching a section that is still wet. For tonal drawings, Helck used a ruling pen and Artone Extra Dense Black Waterproof Ink, a brand he discovered after years of experimenting. He found that he could achieve a far deeper black in large areas by working with a ruling pen than with brushes. Even for color finishes, he often began with an ink drawing.

Helck believed that "textures give animation, vitality, and added interest to drawings and paintings." He used a variety of unconventional methods and tools to achieve these enlivening textures: a toothbrush (for spattering), a tea strainer (paint was pushed through the holes with a bristle brush), wads of cotton, rubber bath sponges,

pipe cleaners, painting knives, a wire brush, painting rollers, and even dental tools.

When an assignment called for color, Helck usually worked in gouache, one of the most water-soluble of all water-based mediums compared to tempera and casein, which are water-resistant when dry. In the early stages of a gouache painting, he used a roller to create large areas of flat color. When dry, he transferred his pencil drawing onto the color surface. This had the effect of organizing his picture into logical relationships, and from there he developed the details. Although he usually didn't use oil for commercial work, his procedure in that medium was similar. He began with a pencil or ink drawing, then laid over repeated washes of thinned-out oil color, creating a gradual buildup of depth and texture.

Peter Helck
Cornstalks in a field
Ink and gouache on board

FRED LUDEKENS

Fred Ludekens began every illustration by making a number of thumbnail sketches to clarify his picture concept. His next step was a more complete drawing on tracing paper, usually the size of the published illustration, which showed him exactly what the observer would see when his image was in print. In that pencil study, he concerned himself with masses of shape and form and their position in the picture. Very few details were included at that stage, as these were rendered in the final painting, where he could refine them as needed.

Once he was satisfied with his composition, he transferred the drawing from the tracing paper to Whatman illustration board using a camera lucida. This device, which was used by many illustrators, projected the original image onto blank paper so that it could be easily transferred to the final painting surface. It also allowed the artist to enlarge or reduce the original sketch. Shown at right, Fred Ludekens using a camera lucida to transfer his barroom fight scene to board (see pages 77–79).

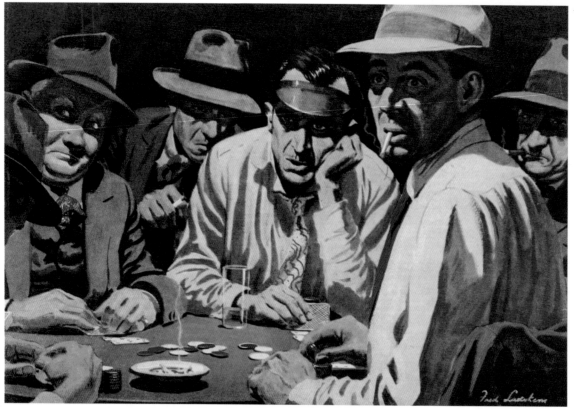

Fred Ludekens
Story illustration for
The Innocent and the Guilty
by Norman Katov
The Saturday Evening Post,
May 13, 1950

AL PARKER

An artist who valued experimentation, Al Parker was an artistic chameleon who avoided being identified by just one style. In fact, he once used a unique approach for each illustration in a single issue of *Cosmopolitan* magazine, signing his images with pen names. Equally versatile in his choice of medium, he said, "I have worked in pencil (carbon, graphite, China marking, indelible and the type which is soluble in water), tempera, watercolor, gouache, oil, wash, airbrush, pen and ink, dry brush, charcoal, pastel, crayons, colored inks, and I have used photographs in a collage. I have worked on paper, glass, wood, gesso panels, canvas and fabric."

Underlying Parker's signature versatility was his reliance on a very practical tool: his research file, in which he collected pictures, photographs, sketches, and notes of how things looked. Nowadays, of course, online information is readily available, but the founding

artists each had to assemble his own visual references. As shown in the photograph, Parker kept his in steel file cabinets, with carefully labeled folders that helped him quickly find the pictorial reference—sometimes referred to as "scrap"—that would lend his illustrations the necessary authenticity. Mannequins, like the one seen on top of Parker's files, allowed him to experiment with dramatic lighting effects on the human form in lieu of a model.

Even for today's artists, Parker's advice regarding reference materials still holds true: "If possible, make a personal inspection of the object pictured in your scrap. Your file will show you what it looks like, and can create the mood and start you on a rough sketch, but do not allow this to be the end of your research if you can see the object itself. Your file can tell you that the object comes in several colors or sizes, but it can't tell you as much as the article itself can say."

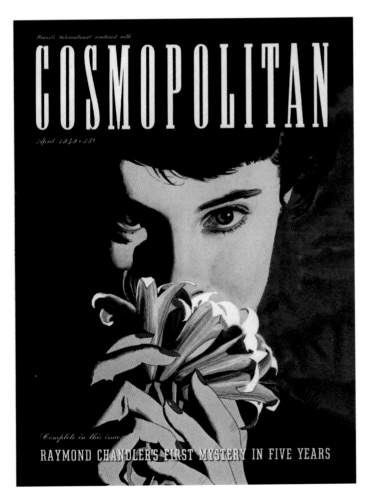

Alfred Charles Parker
Woman with Lily,
Cover illustration for
Cosmopolitan, April 1949

NORMAN ROCKWELL

For Norman Rockwell, the charcoal drawing was the perfect intermediary step between his rough thumbnail concept study and his final oil painting. By the mid-1930s, his meticulous artistic process also included the careful selection of local models, who were coaxed into poses that suited his narratives and then photographed to capture impossible-to-hold gestures and expressions. The resulting photographs were arranged and projected onto drawing paper with the aid of a Balopticon, a still projection lantern that became an important compositional tool for the artist. While many artists used projection devices surreptitiously in their process, Rockwell was very up front about the Balopticon's usefulness. Although he claimed to feel guilty about it, he said, "I comfort myself with the thought that many of the great painters used aids to drawing: the camera obscura, the camera lucida, mirrors, et cetera."

For Rockwell's charcoal drawing, composed at the same size as the final painting, he worked on architect's detail paper, which has "a slight sizing on the surface so, before I draw, I go over it very thoroughly with a kneaded eraser. Then all areas will take the charcoal uniformly." As for charcoal, he worked with Fusains Rouget No. 3 sticks and Wolff's carbon pencils, a mixture of charcoal and graphite, which were blended with his thumb and fingers rather than a paper stump or cloth. After completion, Rockwell's charcoal drawing was then photographed, and his photographic prints became substrates for color studies created in oil.

Once Rockwell's final image was transferred to canvas, he created an underpainting in a single color, such as raw umber or vermillion, diluting and wiping his paint with rags to capture areas of light and dark. His underpainting was sealed with French retouching varnish so that his later work would not disrupt it. He then went on to rapidly lay in prominent colors. "Don't do this lay-in too carefully," he said. "You want some accidents to play with." Rockwell preferred Winsor & Newton, and sometimes Shiva oil paints, arranged on a standing glass palette from warm (left) to cool (right). Depending upon his artistic goals, he moved between an impasto or opaque method of painting and a traditional glazing approach, in which layers of thin washes of color are applied over the underpainting to achieve richness and depth.

Norman Rockwell
Posing as a model and study for *The Common Cold: The All Out Remedy for the Patient Who Is All In*, 1945
Illustration for *The Saturday Evening Post*, January 27, 1945

BEN STAHL

Ben Stahl's preferred tools for sketching were black chalk, grease crayon, or pencil on smooth bond. Sometimes, he added a casein wash or brush and ink. In his drawings, he created tone by dipping charcoal into india ink, then smudging it on paper, a trick he learned from Peter Helck. Stahl often worked in casein paint, a fast-drying, water-soluble medium derived from milk protein. Stahl said, "I've mixed just about everything with casein, from india ink to oil color, and have never found a combination that didn't work."

At the beginning stages of a painting in casein, Stahl would make his preliminary drawing on a toned surface with a No. 5 sable watercolor brush. At this point, he handled the casein the way he would watercolor—transparently. After the drawing was established, he laid in the first tones with bristle brushes. At first, Stahl used very wet paint, but as the painting progressed and the details were refined, his paint became drier and thicker, giving him more control. He continued with bristle brushes, because he needed a tool that would

make it easier to scumble and, at the same time allow him to apply "rich gobs of paint." Scumbling is a technique in which scratchy or speckled colors are layered upon one another, softening the edges of form and creating texture and depth. Moving forward, he switched from harder bristle brushes to softer sable brushes, to create a variety of effects. Another favorite Stahl tool was a single-edge razor blade. He always kept a supply handy for scraping off excess paint and creating interesting textures.

Ben Stahl
Sketch, *Woman with Wine Glass*
Pencil on paper

HAROLD VON SCHMIDT

When discussing his thirty-six years as an illustrator, Harold von Schmidt divided them this way: "About thirteen years of painting with tempera or gouache, probably three years when I worked in both, and the last twenty years of painting mostly in oil." He went on to qualify further: "Over this period some jobs were done with a pen, one with charcoal, many with line and tone and many more dry brush drawings." In other words, like many of his fellow illustrators, von Schmidt did not limit himself to any one approach. Rather, he used the tools that were best suited to each particular job. Even so, he had his preferences. About making preliminary drawings, he wrote, "Many illustrators use ink beautifully but it runs and slips away from my brush and hand, so I use the more familiar paint."

He credited his early background as good training for his varied career. When he was just starting out in San Francisco in 1914, he wrote, " . . . there was not enough art work in any field to go around. To keep eating we had to do every kind of graphic art in the medium requested. It was fine training. It included the retouching of photographs, lettering, designing sheet music covers, labels for cans and

packages, fiction and advertising illustrations, and working with printers in the designing of books from the dummy to the finished volume. I did not know enough to fear a change in medium. There was a job to be done and I tackled it."

By the time von Schmidt established his reputation on the East Coast, he had abandoned tempera and watercolor and was painting exclusively in oil. At a time when, as he said, 90 percent of all illustration was painted in water-based media, he persisted in painting in oil. He wrote, "I hope this proves that it is not how you work but what you say with paint that counts."

Harold von Schmidt
Persian cat studies
Gouache, ink, and
pencil on board

JON WHITCOMB

Jon Whitcomb freely admitted that his "pet" medium was watercolor, both transparent and opaque. In fact, he wrote, "I regret that I am completely unskilled in the medium of oils, [even though] there are effects possible in oil painting that are not feasible in any other medium." However, this preference did not really limit the scope of his production, as he found many ways to vary his effects by exploiting his favorite mediums and even combining them.

For painting in watercolor, Whitcomb used opaque Winsor & Newton Designers Colors (gouache) and casein white on Whatman illustration board. As a glamour illustrator, Whitcomb was known for his pictures of beautiful women, handsome men, and celebrities, so his techniques for creating realistic and appealing faces were well developed. His advice for blending skin tones from light to shadow: "Adjacent light and dark areas are blended with a bristle brush which has been dipped in an intermediate tone. This works best when the paint is more dry than wet. For even smoother effects some casein medium can be mixed with the color. This slows up drying and gives you more time to work."

Whitcomb liked to paint sitting down; everything in his studio was on wheels so it could be moved around as needed. As palettes, he used butcher trays with a white enamel finish, as did a number of his fellow artists. He claimed not to be particular about brushes, but said, "I like them when they are new and hate them when the point has worn off." As for colors, he preferred to use them straight from the tube, lined up beside him in color-spectrum order. "It seems to me that no mixture of red and yellow on the palette is ever as bright as the manufacturer's orange. Mixing the stuff is always a last resort."

His working method was the result of long years of experience at turning out advertising illustrations on tight deadlines. He described the process this way: "I like to work all over a drawing at once so I can keep a color and tone balance across the whole thing. . . . Several times during the progress of a drawing, I spray it with a thin film of lacquer. This keeps pencil marks from rubbing off and the early layers of watercolor from mixing with whatever I feel like putting on next. The fixative also keeps certain colors from bleeding through lighter washes applied later on top."

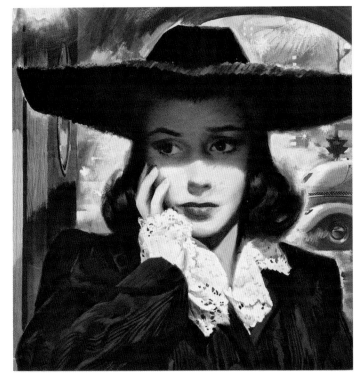

Jon Whitcomb
Story illustration for *Julie* by Ruth Babcock,
Ladies' Home Journal
August 1947

ABOUT THE AUTHORS

Stephanie Haboush Plunkett is the deputy director and chief curator of Norman Rockwell Museum. Born and raised in Brooklyn, New York, she is the recipient of a bachelor of fine arts degree from Pratt Institute and a master of fine arts degree from the School of Visual Arts, and has served as the curator of many exhibitions exploring the art of Norman Rockwell and the field of illustration. Plunkett began her professional career in the field of museum education at the Brooklyn Museum, where she designed and taught programs for children, school groups, and families, and she has also held positions at the Brooklyn Children's Museum and the Heckscher Museum of Art in Huntington, New York. She lives in Pittsfield, Massachusetts.

Magdalen Livesey is president and managing editor of Cortina Learning International, Inc., publishers of distance learning materials in foreign languages and English as a second language and of the Famous Artists Schools (FAS) Courses in painting and commercial art, writing, and photography. She has worked closely with the FAS guiding faculty on updates to the classic art courses while supervising the publication of online versions of the Art Foundations, Painting, Illustration/ Design, and Cartooning courses. She lives in Wilton, Connecticut.

About Norman Rockwell Museum

Norman Rockwell Museum, located in Stockbridge, Massachusetts, holds the largest and most significant collection of art and archival materials relating to the life and work of legendary American illustrator Norman Rockwell and a growing collection of original illustration art that reflects the vibrancy, evolution, and resilience of the field—from the emergence of printed mass media in the mid-nineteenth century to the innovations of digital media today. Illustration is the art of the people—at once the most democratic and influential form of art. Through our dedication to this expansive body of materials, which have reflected and shaped American popular culture, we seek to examine the nature of published images and their integral presence as artistic and cultural artifacts through time. Visit www.nrm.org.

IMAGE CREDITS

The copyrighted images appearing on the following pages are reproduced by permission, © **The Norman Rockwell Family Agency**, all right reserved: pages 12, 25, 28, 29, 37, 45, 51, 67, 84, 88, 93, 97, 104, 105, 107, 118, 141, 152.

The copyrighted images appearing on the following pages are © SEPS: Licensed by permission of **The Curtis Publishing Company, Indianapolis, IN**, all right reserved: pages 20, 23, 26, 44, 52, 65, 74, 75, 76, 83, 89, 92, 100, 110, 142, 150.

Shutterstock.com: page 129 (top).

OTHER CREDITS

Page 106
Gossips photomontage designed by Ron Schick.

Page 147
Quote courtesy of David Apatoff, *Albert Dorne: Master Illustrator*, Auad Publishing, 2013.

ARTWORK CREDITS

Norman Rockwell Museum Collections

All Famous Artists School artworks and photographs from the Norman Rockwell Museum Collection, which appear throughout the book, were generously donated by **Magdalen and Robert Livesey**.

Additional artworks by Norman Rockwell and other artists from Norman Rockwell Museum Collection: pages 12, 14, 15, 16, 24, 25, 36, 37, 40, 45, 47, 50, 54, 84, 87, 88, 95, 104, 106, 116, 118, 123, 152.

Additional photographs from Norman Rockwell Museum Collection: pages 14, 15, 16, 51, 98, 99, 152.

Other Collections

The D.B. Dowd Modern Graphic History Library, Washington University, in St. Louis, MO: pages 18, 39, 70 (top), 101, 109, 142

Collection of George Lucas: pages 97, 107

Illustrated Gallery, Fort Washington, PA: pages 25, 66

The Kelly Collection of American Illustration Art: page 66 (bottom)

The Society of Illustrators, New York: page 61

The Los Angeles County Museum of Art, Los Angeles: page 51

INDEX